BLUE

U E

Cobalt to Cerulean in Art and Culture

From the Collection of the
Museum of Fine Arts, Boston

CHRONICLE BOOKS
SAN FRANCISCO

mfa
BOSTON

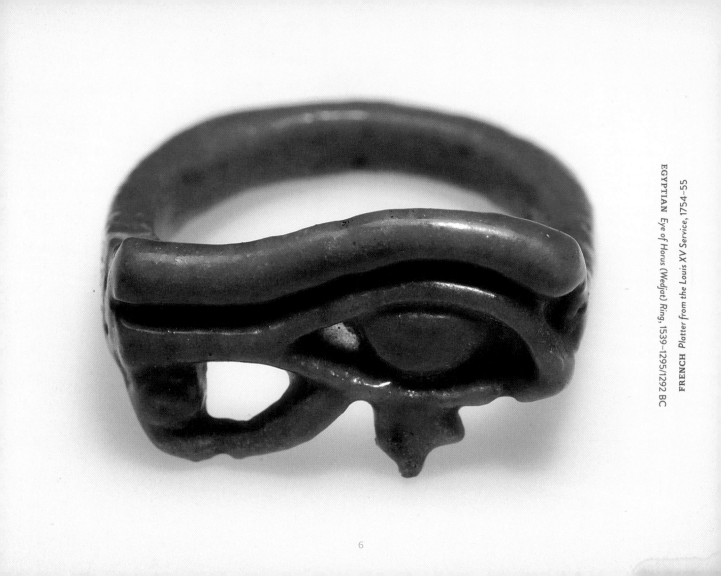

EGYPTIAN *Eye of Horus (Wedjat) Ring,* 1539–1295/1292 BC

FRENCH *Platter from the Louis XV Service,* 1754–55

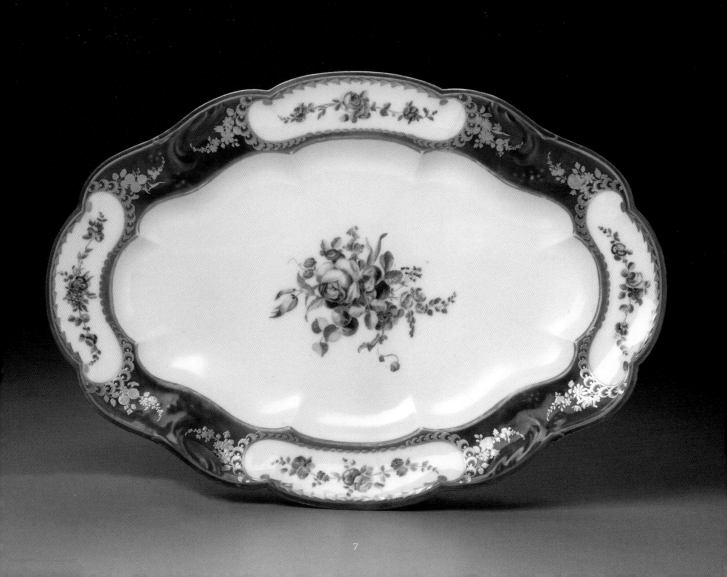

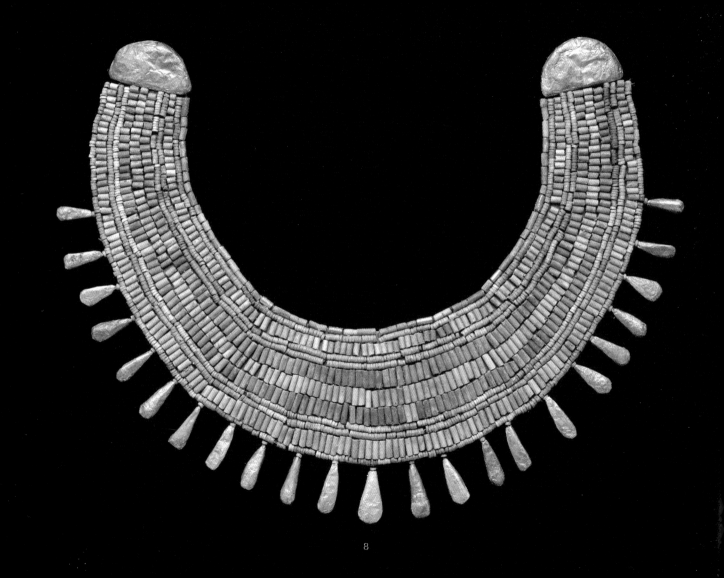

8

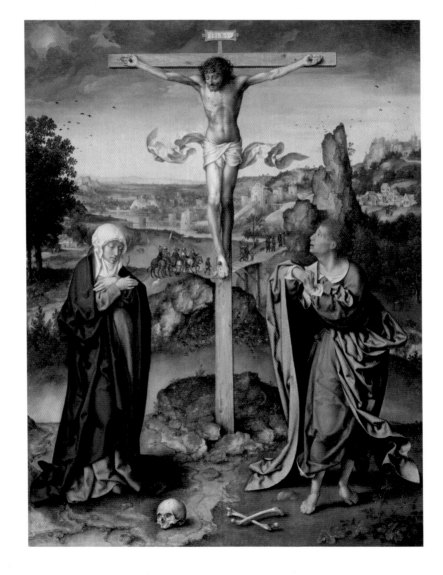

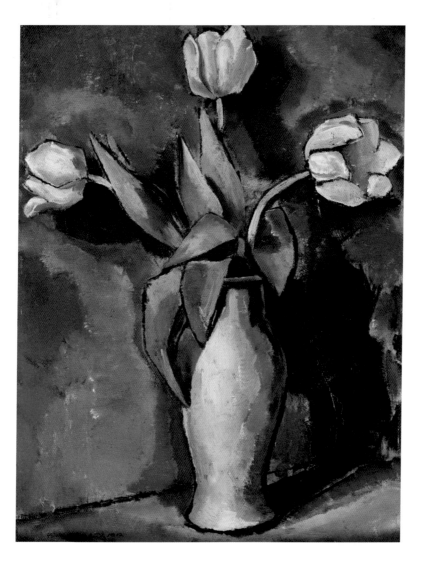

CHARLES SHEELER *Three White Tulips*, 1912

EGYPTIAN *Ibex Finial*, 1550–1295 BC
EGYPTIAN *Model Throw Stick*, 1400–1390 BC

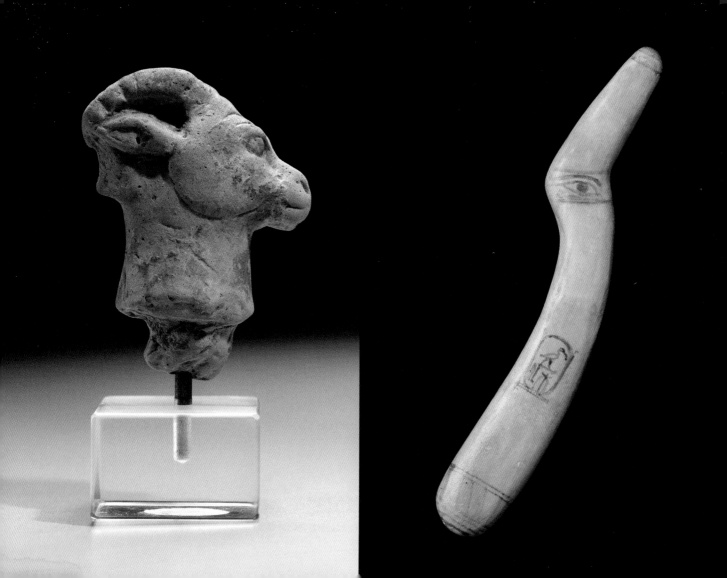

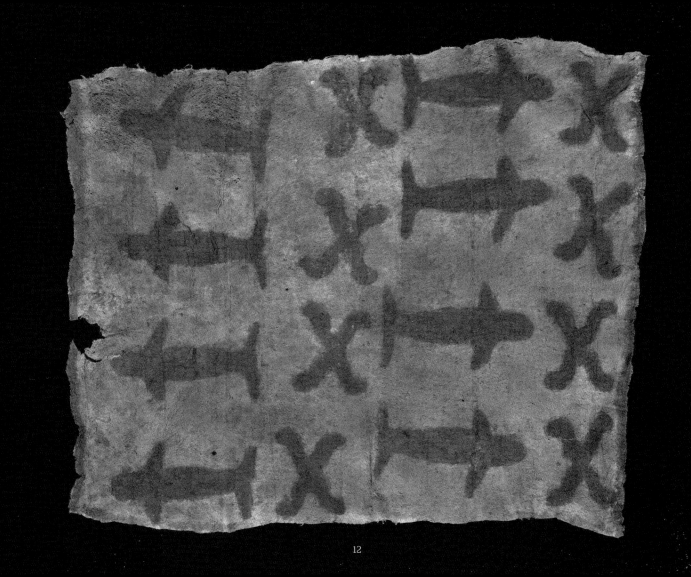

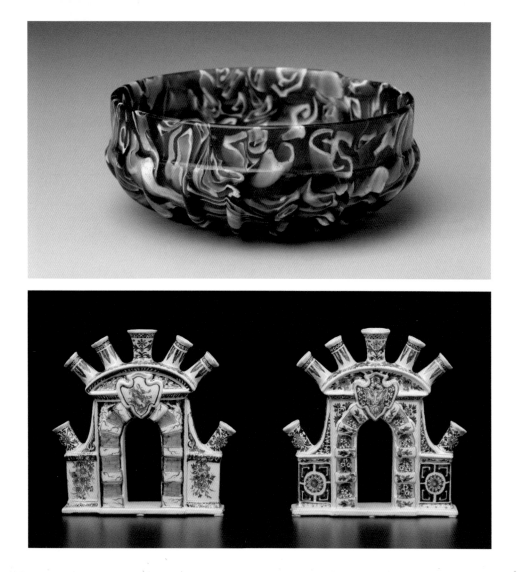

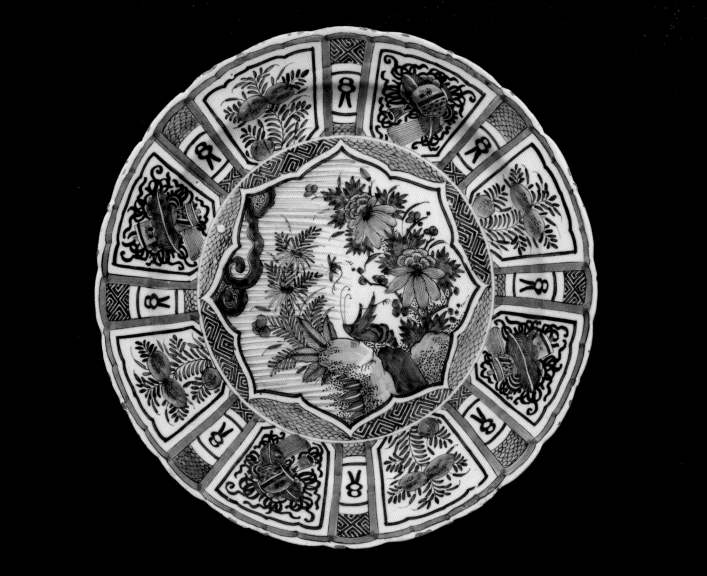

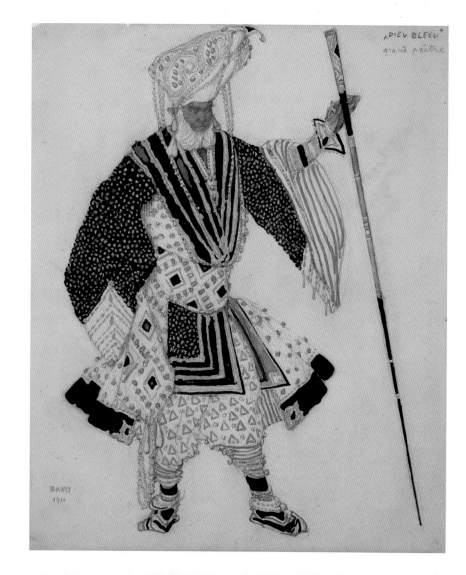

"DIEU BLEU"
grand prêtre

BAKST
1911

Introduction: Blue Notes

Adam Tessier

Head of Interpretation

EVERYONE LOVES BLUE. Four in ten people would tell you it's their favorite color. To be fair, though, four in ten people will also say the cashew is their favorite nut. That same percentage of adults still reads actual newspapers, and an equal number believes ghosts are real. So for a moment, let's set aside the fact that you and I and about 40 percent of everyone we know prefer blue over any other color. Instead let's wonder: What does that preference reveal about us? What does *blue* say about us? In the pages that follow, images from the Museum of Fine Arts, Boston, and essays by ten of the museum's curators and conservators explore that question, providing a rich (and colorful) context for humankind's fascination with blue across thousands of years of art making and cultural history.

Make a list of everything blue, a stream of blue consciousness. Mine would begin: Picasso's Blue Period. Joni Mitchell's album *Blue*, with its cyan sleeve. Miles Davis, *Kind of Blue*. My favorite blue oxford-cloth shirt. The perfect blue jeans. Elvis and his blue suede shoes. The deep blue of the bull-leaping fresco at Knossos, or better, the brilliant blue backdrop of Babylon's Ishtar Gate. The blue glass in the windows at Chartres. The Hope Diamond. Tiffany's little blue box. Sapphires. Smurfs. Thomas Gainsborough's *Blue Boy*. Cornflowers. Blue jays. Blue books for exams, and blue pens. French chore smocks, called *bleu de travail*, "work blue." My mother's Blue Willow plates, the pattern rubbed off at the edges. And above all, the sky, and then also the sea.

Or to the ancient Egyptians, the sky and the Nile, and by extension the gods who ruled those realms. As blues go, the Egyptians famously invented two: Egyptian faience, a glassy blue ceramic, and so-called Egyptian blue, the first synthetic pigment ever made. But their most precious blue came from the faraway mines of Afghanistan, in the form of the rock lapis lazuli. Ground to powder, lapis becomes ultramarine, at one point the costliest pigment in existence—a luxury rarer even than gold. Renaissance painters reserved it for only the most special applications, like the painted robes of the Virgin, a blue proper for the queen of heaven. A *true blue*. Which brings us to the medieval fabric that gave rise to that phrase: the blue cloth dyed at Coventry, England, and whose color did not fade.

For a while, everyone wanted that blue Coventry wool. Green may be the color of envy, but blue is the color we covet. We've hunted it down, prized it, copied, borrowed, and sometimes been left to create it ourselves out of thin air. One region's blue often began somewhere else. The origins of China's beloved blue-and-white porcelain were in West Asia. From China, blue and white made its way to Japan, and throughout Asia, and then on to Europe, where it found a feverish market of admirers, as well as copyists laboring to decode its mysteries. Along the way came the blues of Vincennes, Sèvres, Delft, Wedgwood's blue jasperware, and the ubiquitous transfer-printed Blue Willow pattern.

As far as I can tell, blue has never meant just one thing. In the seventeenth century, Dutch painters placed blue-and-white Chinese porcelain in their still lifes as symbols of luxury, while in ancient Rome, blue was a color of the working class—the original blue collar. For fancier blues, the Romans used dye from the indigo plant, which today gives my everyday blue jeans their shade. Hokusai used indigo, too, in parts of his print *The Great Wave*. But when it came to depicting the wave itself, he favored the exciting new Prussian blue, brought to Japan by Dutch traders. In turn, the Dutch artist Vincent van Gogh chose the same blue for his pulsating skies. These connections continue. As I write this, Pantone has announced the color for spring 2014: Dazzling Blue, which, as it happens, is also Facebook blue.

Is that what blue is all about? Connections? Think of the blues—that most essential emotion and musical form. The "blue note" in every blues song, its pitch bent a little, flattened, instantly signaling a feeling we've all shared. "Am I blue?" Billie Holiday sang. The poet Gayl Jones, listening to Holiday, writes:

The blues calling my name.
She is singing a deep song.
She is singing a deep song.
I am human.

Maybe that's it: Blue reminds us of what we are. It brings us down to size. Blue stands for something bigger than any one of us. The Nile and the sky, the limitlessness of water and the heavens. I'm thinking now about Neil Armstrong looking back from the moon. From where he stood—nearly a quarter-million miles away—home was "a tiny pea, pretty and blue." Holding up his gloved hand and closing one eye, he could blot out that blue speck in the sky with his thumb. Doing so, he said, made him feel small.

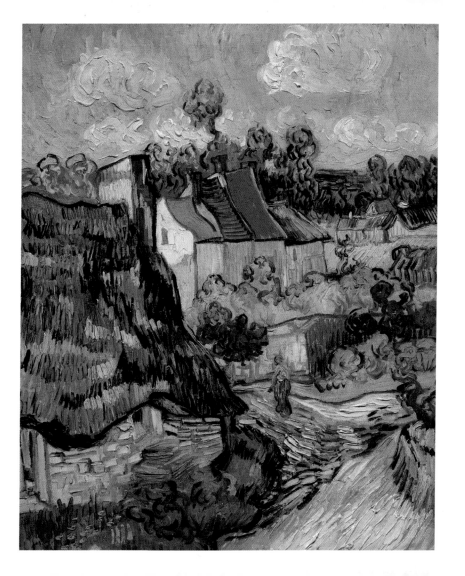

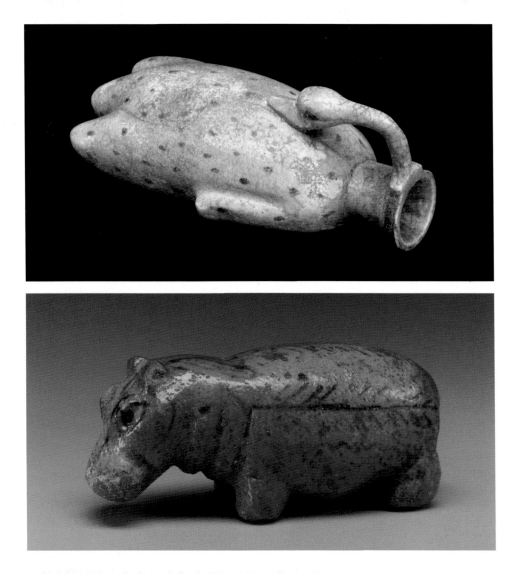

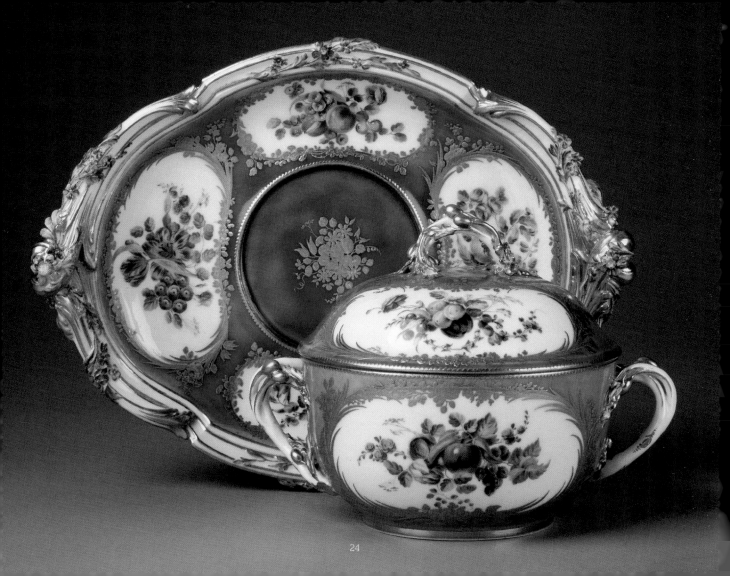

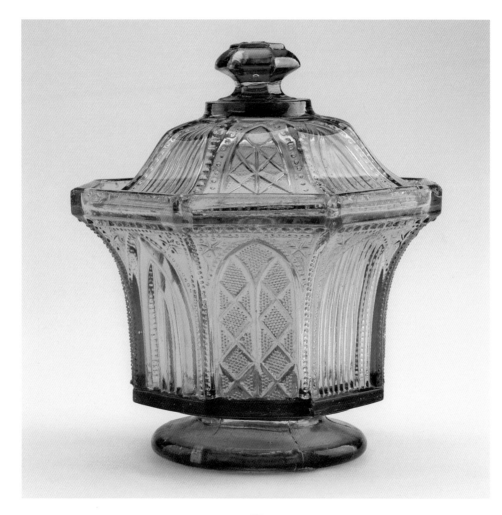

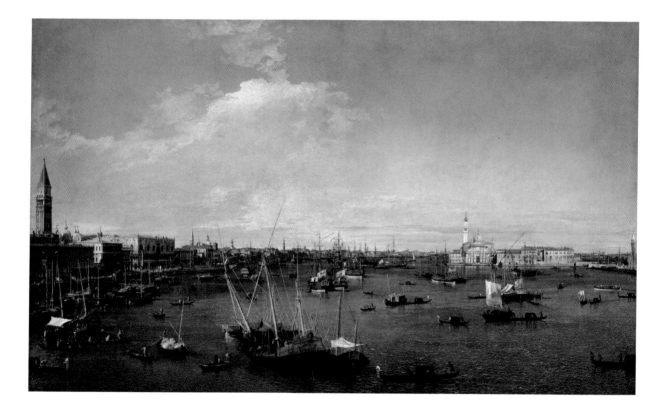

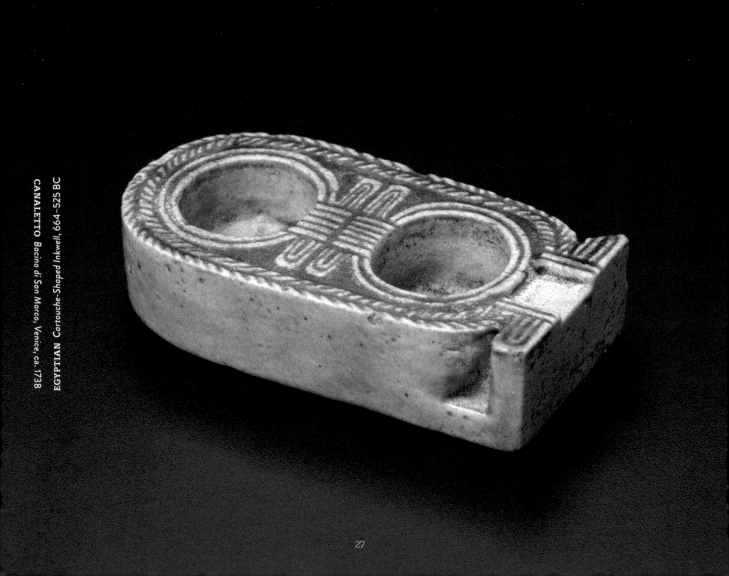

EGYPTIAN *Cartouche-Shaped Inkwell, 664–525 BC*
CANALETTO *Bacino di San Marco, Venice, ca. 1738*

The Significance of Blue in Ancient Egyptian Art

Denise Doxey

Curator of Ancient Egyptian, Nubian, and Near Eastern Art

clockwise from top left: **EGYPTIAN** *Ointment Jar in the Form of a Trussed Duck,* 1991–1550 BC
Amulet of Ra-Horakhty as a Falcon, ca. 1070 BC–30 BC
Winged Scarab Pectoral, 760–332 BC

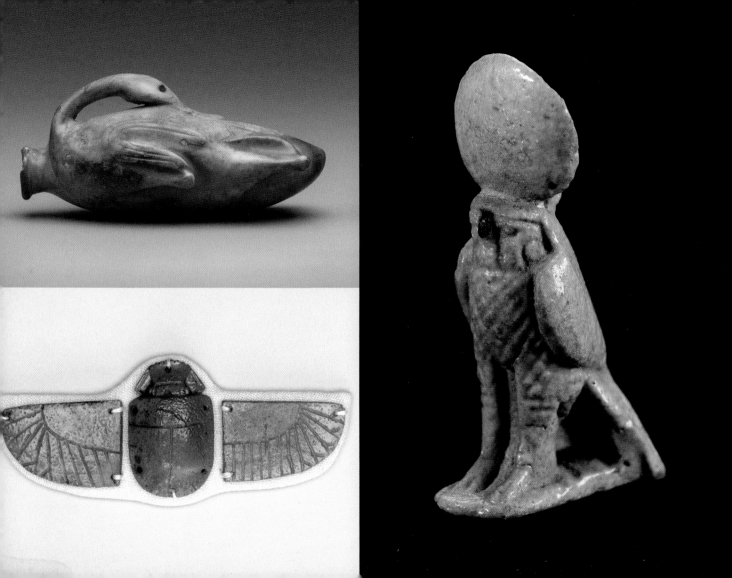

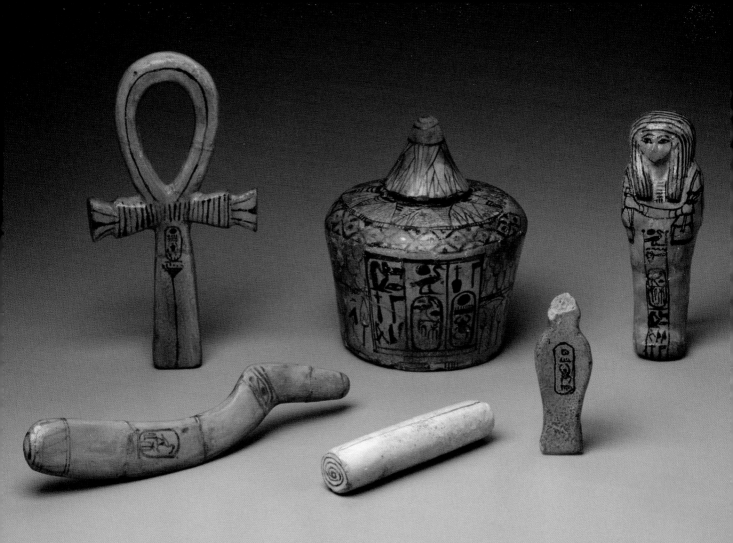

TO THE ANCIENT EGYPTIANS, colors were rich in symbolism and even imbued with magical properties. Materials were carefully selected for their color. Blue enjoyed particularly positive connotations, and because most blue stones were unavailable locally, the Egyptians went to great lengths to procure blue minerals or create blue substances for their artists and artisans to use. From a very early date (prior to 3500 BC), they were importing lapis lazuli from as far away as Afghanistan for manufacturing seals and amulets. Turquoise, also used primarily for amulets, was mined in the southern Sinai Peninsula. Between about 1800 and 1550 BC, anhydrite, a rare pale blue stone, was used to create small jars and vessels, sometimes in the form of animals such as ducks (see page 29). The invention in about 3000 BC of Egyptian faience, a silica-based nonclay ceramic material, gave the Egyptians a readily available means of producing objects like amulets, vessels, and small-scale sculpture with a bright blue finish, a method that was perfected over time. Blue glazes were also applied to scarabs and amulets made of steatite, a soft stone popular with Egyptian craftsmen.

Not surprisingly, the color blue was closely linked with the sky and with related gods and goddesses, such as the sky god Horus and the sun god Ra, both of whom were portrayed as falcons (see page 29). The image of the sun rising on the horizon, Ra-Horakhty, became a potent symbol of rebirth and resurrection. The morning sun was portrayed as the scarab beetle, Khepri. Blue scarab amulets and seals became ubiquitous (see page 33), and blue scarabs featured prominently in funerary ornaments that adorned mummies and helped to ensure that the deceased would be reborn in the afterlife (see page 29). The blossom of the blue lotus or water lily, which closed up at night to reopen in the morning, was closely associated with the birth of the infant sun god, and hence with fertility and regeneration. Bright blue faience cups and chalices were therefore not only attractive and functional but also carried a sacred meaning (see page 33).

According to Egyptian mythology, the left eye of the sky god Horus was lost in battle and miraculously restored. The eye of Horus, or *wedjat*, thus became an extremely popular symbol of protection, health, and rejuvenation. *Wedjat* amulets, typically rendered in blue faience or lapis lazuli, were among the most popular amulets throughout most of ancient Egyptian history (see pages 33 and 111). Such eyes also appear on blue faience plaques and openwork rings, though the rings would have been too fragile for everyday wear and must have been reserved for ceremonial and funerary use (see page 6).

The color blue also symbolized the life-giving waters of the Nile, without which Egypt would have been an uninhabitable desert, and the Nile's marshes, which produced a large portion of Egypt's food supply. Blue therefore became closely linked with life, and hence with fertility. Blue faience bowls, cups, and other vessels were often decorated in black paint with marsh motifs including plants,

fish, and birds (see pages 92 and 64). The cow goddess Hathor, who personified joy, music, sexuality, and fertility, was believed to reside in the marshes, and she appears on bowls (see page 122) and cosmetics containers, such as a kohl jar of blue-glazed steatite (see page 137). Another marsh dweller associated with fertility was the frog goddess Heqat, a figure often found on amulets intended to facilitate both childbearing for the living and rebirth for the dead (see page 110). Among the most popular deities believed to protect expectant mothers and young children was the god Bes, depicted as a dwarf with a lion's mane and tail (see page 170). Though not specifically linked to the river or wetlands, he is frequently shown as blue because of this connection with fertility. One resident of the Nile and marshes with decidedly less friendly intentions was the hippopotamus. Blue figurines of hippos, painted with aquatic motifs, were probably intended to harness the creatures' aggressive tendencies for protection against dangers on earth and in the afterlife (see page 23).

Because of both its solar connotations and its relationship to rebirth, blue was an important color for funerary objects. After death, the Egyptians hoped to join the sun god in his journey across the heavens, as a result of which they could be reborn for eternity. During the Old Kingdom (2600–2100 BC), the mummies of elite women wore dresses and broad collars made of blue faience beads (see page 8), and in the Late Period (760–332 BC), blue beaded nets covered the mummies of both men and women (see page 34).

From about 1550 onward, figurines known as *shawabtis*, intended to perform labor in the afterlife on behalf of the deceased, were produced in blue-glazed faience (see pages 150 and 157). Blue faience was also sometimes used to make the canopic jars that housed mummified organs (see page 35). Royal tombs such as that of King Thutmose IV often contained ritual objects such as model throw sticks, ankhs (the hieroglyphic symbol for life), and papyrus scrolls to help the king overcome obstacles en route to the afterlife, as well as *shawabtis* and ritual vessels, all in bright blue faience (see page 30). Faience was a relatively inexpensive and readily available material, not the sort of rare treasure usually associated with royalty, so its use in royal burials points to the material itself—or its color—bearing a special religious meaning.

clockwise from left: EGYPTIAN *Blue Lotus Chalice,* 1479–1425 BC
Scarab, 1550–1295 BC
Eye of Horus (Wedjat) Amulet, 30 BC–AD 364

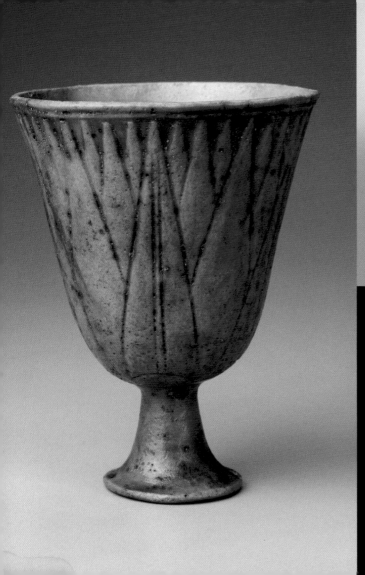
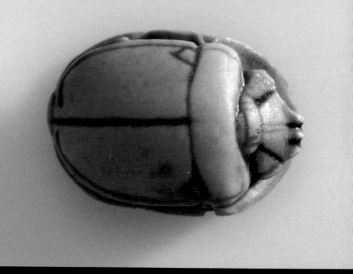
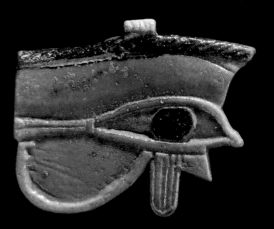

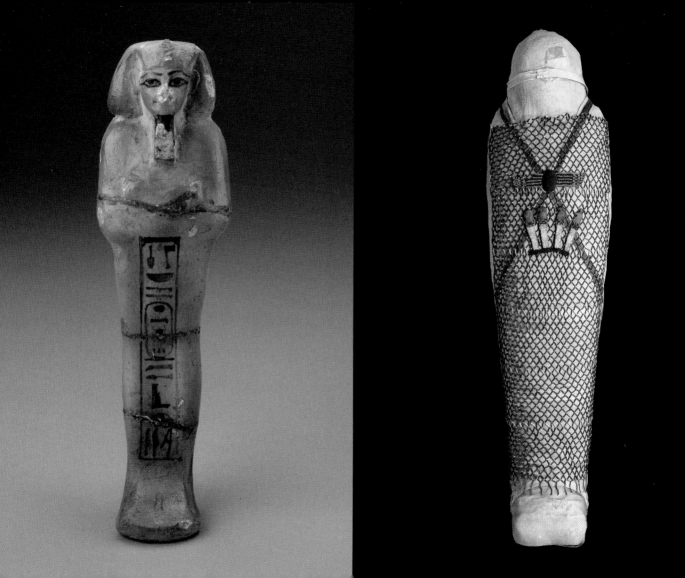

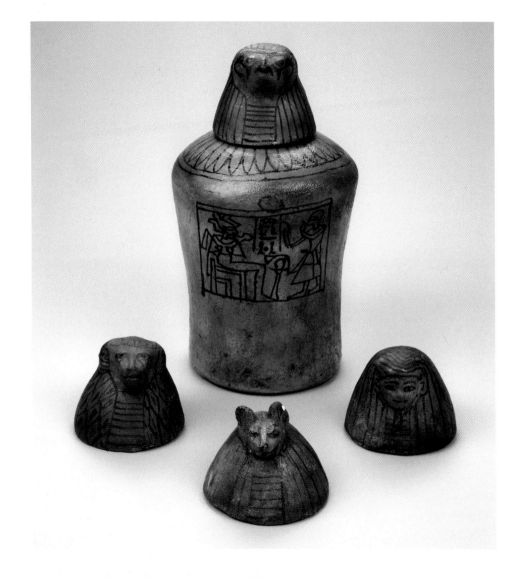

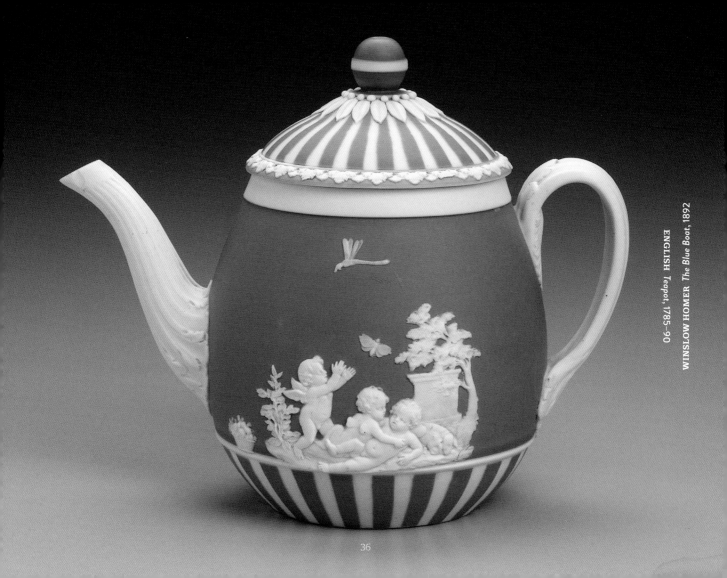

ENGLISH *Teapot*, 1785–90

WINSLOW HOMER *The Blue Boat*, 1892

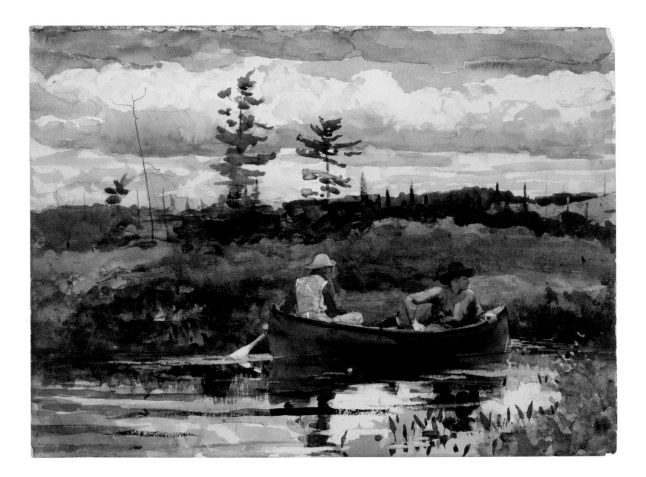

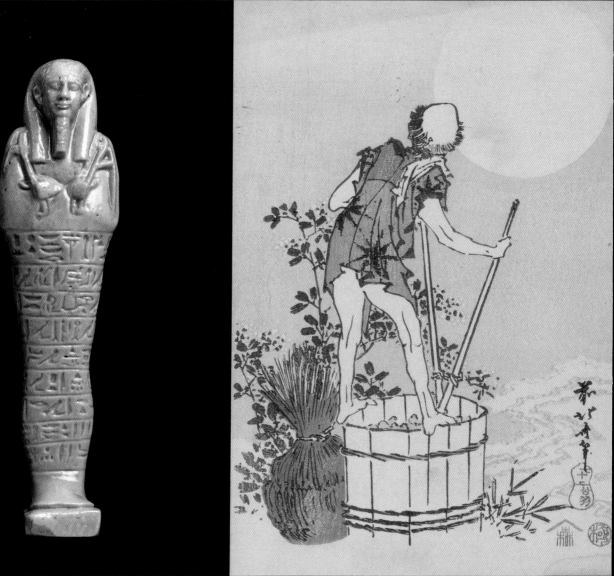

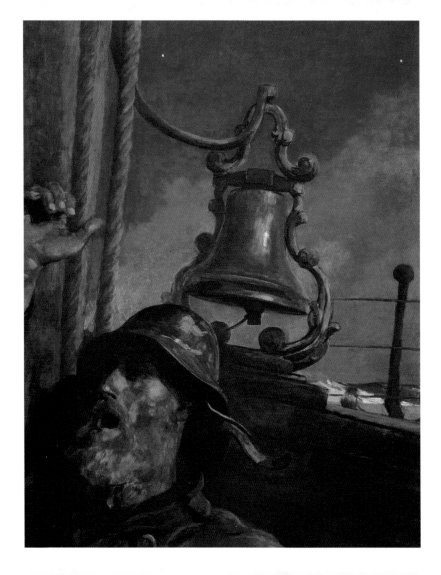

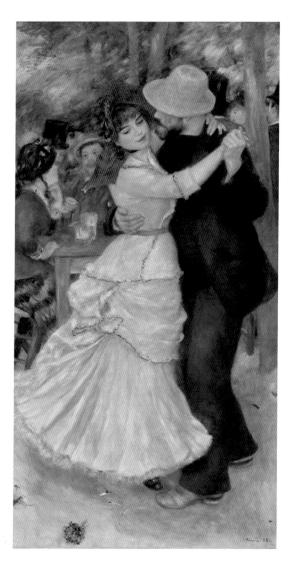

ROMAN *Cameo with Livia Holding a Bust of Augustus (?), AD 14–37*

PIERRE-AUGUSTE RENOIR *Dance at Bougival, 1883*

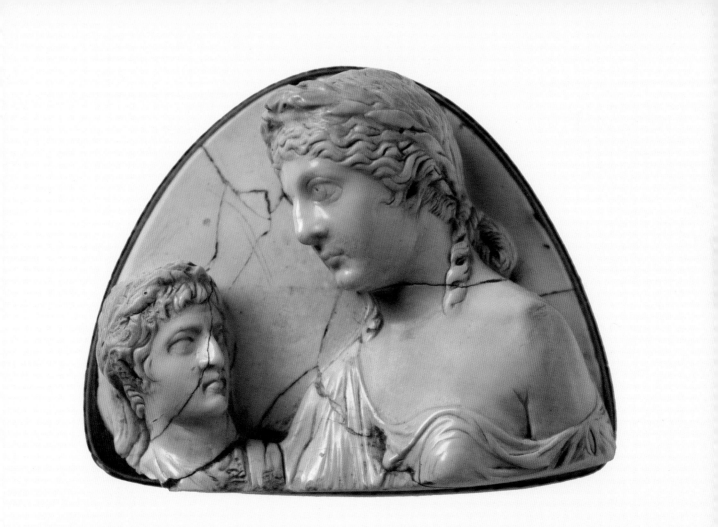

41

Egyptian Blue and Egyptian Faience

Pamela Hatchfield

Robert P. and Carol T. Henderson Head of Objects Conservation

clockwise from top left: **EGYPTIAN** *Vessel (aryballos) in the Form of a Hedgehog,* 664–525 BC
Vessel with Relief Decoration, AD 1–99
Eye of Horus (Wedjat) Amulet, 1550–332 BC

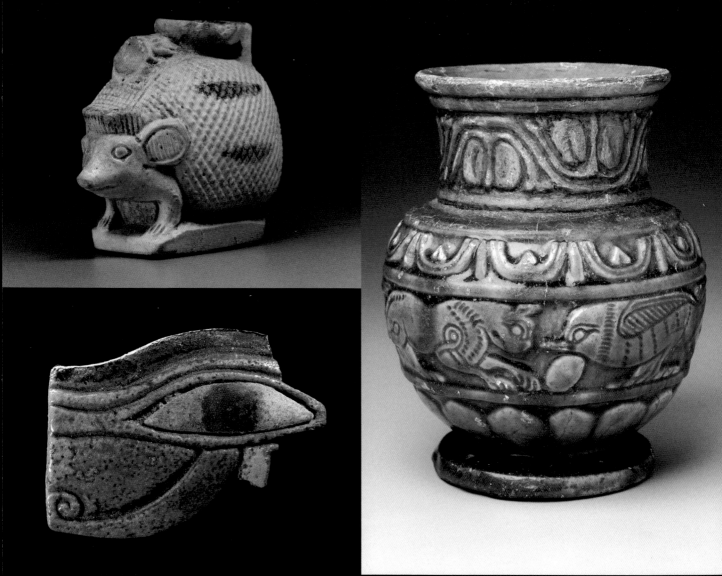

ALTHOUGH THE TERM *faience* has, since the Middle Ages, been associated with colorful tin-glazed earthenware from Europe, the rich blues of Egyptian faience constitute a far more ancient, unique ceramic production. Faience is perhaps the earliest engineered material. Crushed quartz or sand, lime, and alkali were combined to create a whitish core with a fine white ground layer, to which was then applied a soda-lime-silica glaze tinted with copper to form a brilliant blue (see pages 22, 27, 34, 38, 43, and 125). In one variation of this technique, called efflorescence, the glazing materials are incorporated into the body itself. As water evaporated during firing, the copper components migrated to the surface, fusing to form the blue glaze. Shapes were often formed in molds made by casting the shapes of objects such as vessels (see pages 33, 43, 92, 97, and 110), metal finger rings (see page 6), or amulets (see pages 46, 112, 137, 157, and 164). Blue-glazed quartz objects dating from as early as 3100 BC have been found in ancient Nubia. Egyptian techniques for the production of faience (see pages 23, 45, 64, 82, and 107) and glazed steatite (soapstone) (see page 137) were evidently adapted to produce a brilliant, translucent blue over white quartz, perhaps intended to simulate the appearance of precious gemstones. The early-nineteenth-century Harvard University–Boston Museum of Fine Arts expedition to Kerma in the Sudan excavated hundreds of small glazed stone artifacts such as beads (see page 21) but also several extraordinary objects of unparalleled scale and execution (see pages 45,

46, and 154). Kerma was apparently a center for the production of faience and glazed stone. Sculptural objects such as a magnificent, nearly half-life-size lion body (see page 19) and a large scorpion appeared at this site in ancient Egypt (see page 45). These objects were carved from white quartzite and glazed with a brilliant, translucent blue that, when fired, fused to the stone in heat intense enough to temporarily slightly soften the stone itself.

Another blue pigment, Egyptian blue, first produced around 4500 BC, is considered the earliest synthetic pigment (see pages 52 and 54). Like Egyptian faience, it contains silica, an alkali, and copper as a colorant, but with the addition of calcium, often from limestone. Small, intricately shaped objects of similar composition have been excavated in both ancient Mesopotamia and Egypt (see pages 11 and 120). These objects were fashioned from *pâte de verre* (also known as copper frit or molded lapis lazuli) and called *uknû merku* in Mesopotamia, or *hsbd iryt* in ancient Egyptian (see pages 46 and 138). Already exported to Minoan Crete by 2500 BC, this ubiquitous pigment, known for its beauty and immutability, has been found in Luxor, in Pompeii, at the Parthenon, and as far away as Libya, Uzbekistan, London, and Norway.

In composition, Egyptian blue mimics the rare mineral cuprorivaite, which is seldom found in nature and was only identified in 1938. The synthetic form was widely used in antiquity, but its use diminished precipitously after the fall of the Roman Empire until interest in it revived in

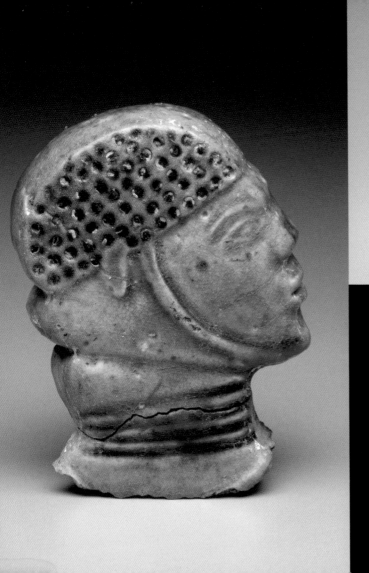

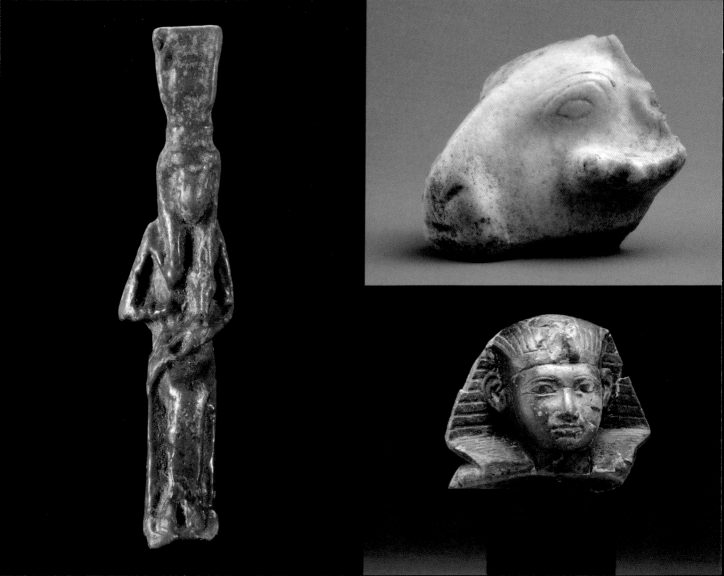

the twentieth century. Today, it is valued by artists for its rich cerulean color, but it is also appreciated by both art historians and scientists for its highly unusual characteristics. Under certain infrared wavelengths of light, it emits a characteristic luminescence (see page 48 detail under normal light [l], and showing traces of Egyptian blue pigment fluorescing bright white under infrared light [r]). This characteristic allows its presence to be identified even when only traces are present—a technique used to reconstruct original color schemes on ancient art. Researchers have recently discovered that it can be broken into nanosheets—sheets so thin that thousands would fit across the width of a human hair. In addition, the distinctive visible radiation emitted by Egyptian blue under certain lighting conditions provides researchers with opportunities to use it in fields as diverse as laser technology, biomedical imaging, telecommunications, and security systems.

Egyptian blue is truly a blue for the ages.

clockwise from left: EGYPTIAN *Amulet of Isis and Horus*, 1070–332 BC
NUBIAN *Head of a Ram, ca. 1700–1550 BC*
EGYPTIAN *Head of a King, 760–660 BC*

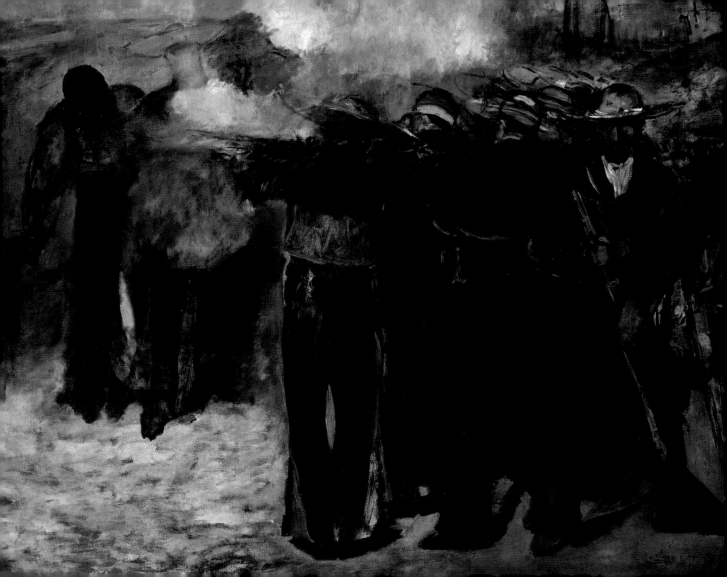

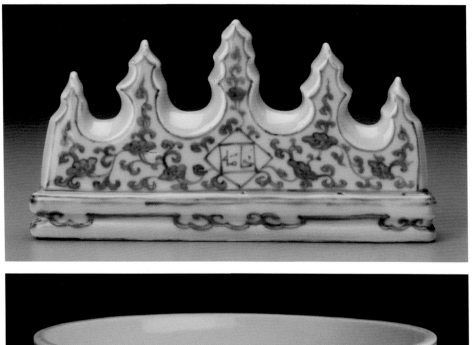

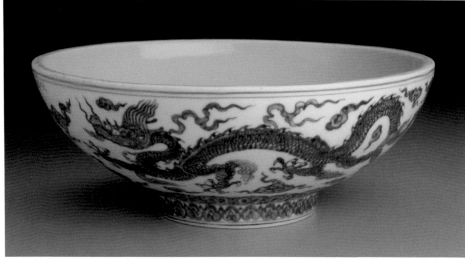

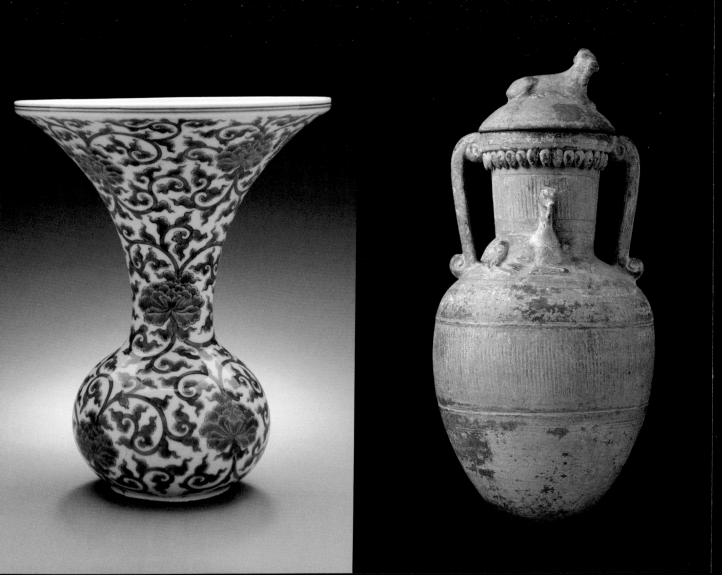

AFRICAN *Woman's Wrapper: Adire Oniko,* mid-20th century
EGYPTIAN *Amphora with Applied Decoration and Lid,* 1390–1327 BC
JAPANESE *Vase,* early 19th century

GIOVANNI BATTISTA TIEPOLO *Virtue and Nobility Crowning Love*, ca. 1759–61

FRENCH *Potpourri in the Form of a Snail Shell*, ca. 1763–68

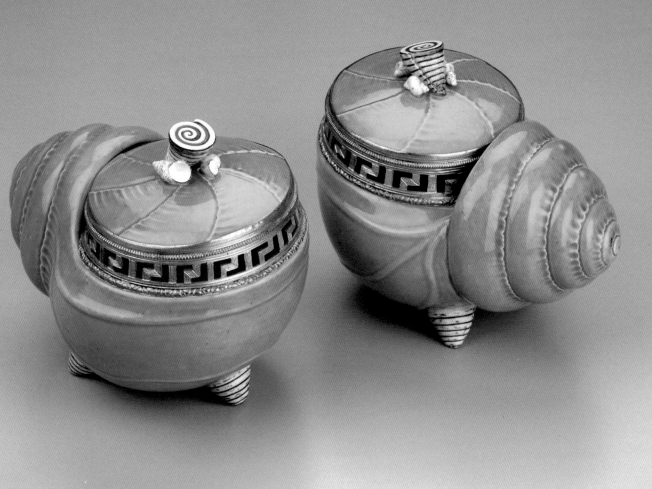

Indigo

Pamela Parmal

Department Head and David and Roberta Logie Curator of Textile and Fashion Arts

INDIAN *Cotton Textile Fragments, in Two Pieces,* probably 14th century

INDIGO BLUE, THE COLOR OF DENIM and the night sky, can be found in clear translucent tones or can appear inky black. The indigoid dye comes from a variety of plants that are grown throughout the world. It is extracted through fermentation and then dried into cakes that can be more easily shipped and traded. In Europe and colder climates, indigo was extracted from the leaves of a flowering plant called woad (*Isatis tinctoria*). In more tropical climates, the plant *Indigofera tinctoria*, true indigo, produces a more concentrated, more easily processed dye. Indigo cultivation and processing probably developed in India, and trade was established with Asia and the Mediterranean world by the second millennium BC. The earliest dated indigo-dyed textiles have been found in Egypt. Tutankhamun owned a blue state robe, and other similarly colored textiles were found in his burial chamber. In Egypt, blue was synonymous with the sky, the heavens, and creation, as well as the life-giving waters of the Nile. As such, it claimed an important symbolic role among the pharaohs (see page 61).

The process of indigo dyeing has its own magic. It occurs through oxidation. Cloth is dipped in a vat of the prepared indigo dye, and the color only becomes visible when the cloth is pulled out and exposed to the oxygen in the air. The cloth magically turns blue in front of your eyes: In the vat water, the cloth is dark blue-green, and then the cloth comes out a pale green-brown and begins to turn blue! The more often it is dipped in the vat, the darker the color. This characteristic of indigo dyeing has been exploited to create a range of blue from light to almost black. The process of vat dyeing makes printing with indigo nearly impossible, and different techniques have been developed to pattern cloth. The majority of these methods involve preventing the dye from penetrating selected areas of the textile or yarn by tying, binding, or covering with a paste. These resist-dyeing techniques developed in Japan, India, Indonesia, and Africa, where indigo dye was available in quantity.

The process of patterning cloth with indigo dye was perfected in India. With the concurrent developments in the use of mordant dyeing with the roots of madder, a perennial climbing plant, to pattern textiles in a range of reds, purples, and browns, the Indians created a major industry and began to export patterned cottons throughout the world. Their cottons were known in the Greco-Roman world, where they reached the Mediterranean through the Arab sea trade into Africa. Thousands of small textile fragments were found in the city of Fustat (Old Cairo) and other archaeological sites dating from the eleventh through the fifteenth centuries (see page 59). The fragments show a range of patterns and colors, indicating that the Indians had developed techniques and a sophisticated market, offering patterned cottons in a wide range of styles and price points.

As indigo cultivation spread throughout the world, different cultures adapted it to suit their own tastes. The Japanese probably developed the greatest range of

61

patterning methods. Indigo dyeing was used to pattern fabric made into clothing worn by people of all social classes. Hemp and cotton textiles were patterned using ikat, tie-dye (see page 167), and a paste-resist technique called *tsutsugaki*, while the wealthy urban merchants wore sophisticated summer kimonos made of cloth on which the color had been hand-painted, then covered with a resist paste before being immersed in indigo (see page 68).

West African indigo dyers also developed sophisticated patterning techniques. In Nigeria, adire cloth is patterned by tie-dye, stitch-resist (see page 55), and by hand-painting or block printing a starch resist. Senegalese dyers used the stitch-resist technique, in which sections of the cloth are bound tightly together and held with stitches, to create intricate patterns on deep blue wrappers (see page 61).

In Europe and other areas with colder climates, the processing of indigo derived from woad was difficult to do, and the yield was low. Indigo plants from tropical climates of India and Africa yielded far more dye, and processed indigo cakes were more easily shipped than the plants. When Europeans began the sea trade to Southeast Asia in the sixteenth century, indigo became one of its most valuable commodities and threatened the woad trade. The Portuguese, Dutch, and then English traders all imported vast amounts of indigo into Europe. In fact, more indigo was imported into Europe than pepper and the rest of the highly treasured spices. Indigo imports from Southeast Asia diminished by the late seventeenth century, when

Europeans began to develop indigo plantations in the West Indies and in North and South America. North Carolina became one of Britain's most important suppliers of the dye. In fact, the first African slaves brought to the Americas used their knowledge of indigo cultivation.

Indigo eventually supplanted woad in Europe and was used in the silk trade (see pages 61 and 97), as well as the developing printed textile industry (see page 62). It remained the most important blue dye until the end of the nineteenth century. It was, in fact, the dye chosen by Levi Strauss to color his denim jeans, first produced in 1873. A synthetic version of indigo was finally invented in 1897 by the German chemist Adolf von Baeyer for Badische Anilin und Soda Fabrik (BASF). Natural indigo and synthetic indigo were both used during the first half of the twentieth century until new artificial blue colors began to supplant them in the marketplace. The post–World War II period, however, saw a renewed interest in indigo dye, as the craze for blue jeans grew. No other blue dye could successfully achieve the worn, faded look so coveted by lovers of denim.

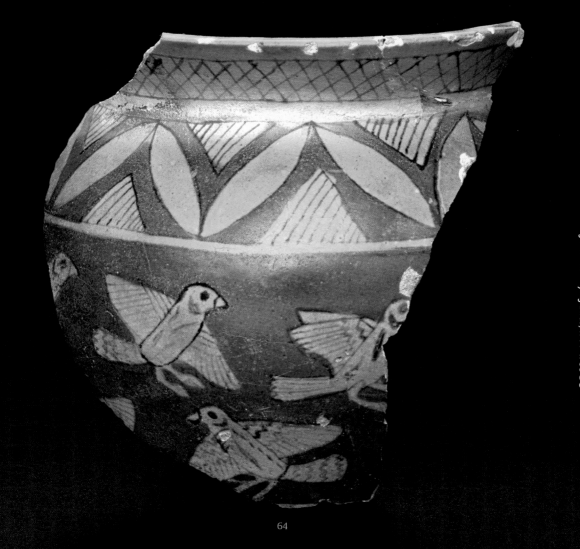

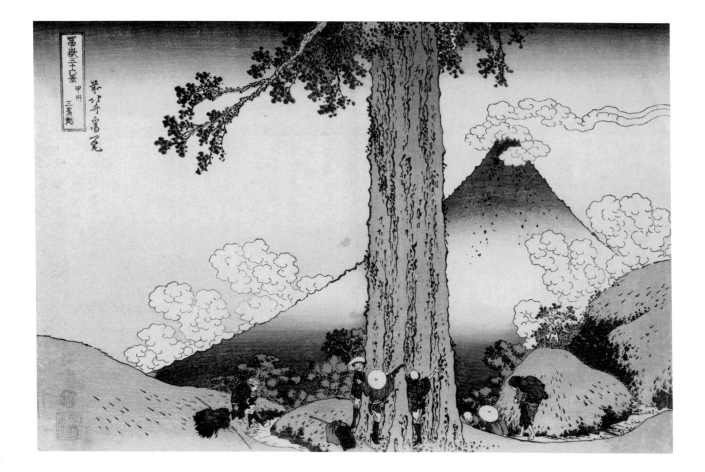

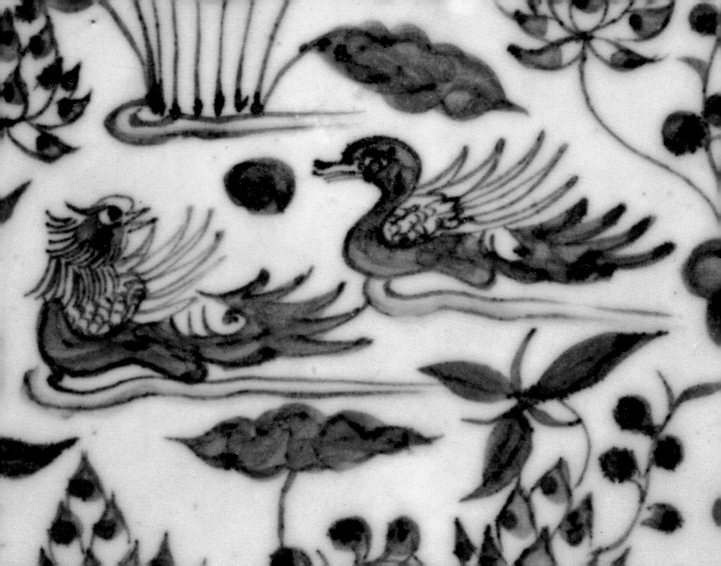

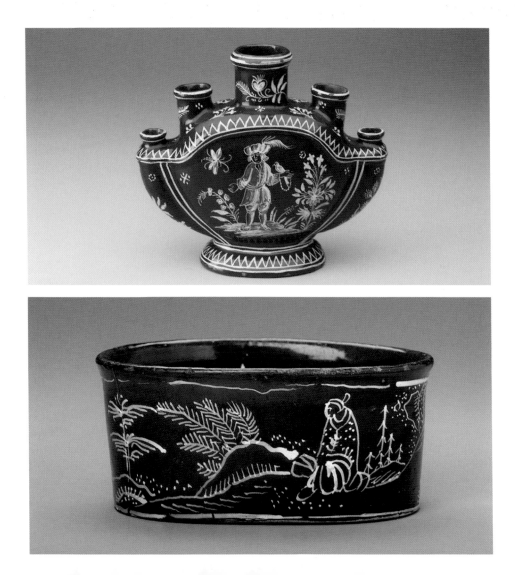

FRENCH *Quintal Flower Vase*, ca. 1740
ENGLISH *Bowl*, ca. 1680

CHINESE *Large Plate with Blue-and-White Decoration of a Pair of Mandarin Ducks in a Lotus Pond* (detail), mid-14th century

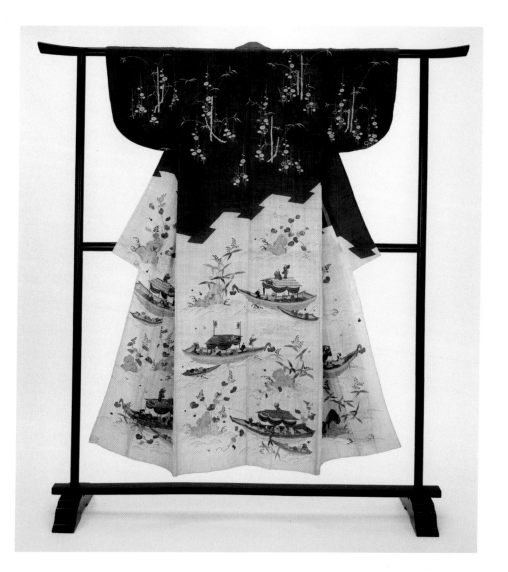

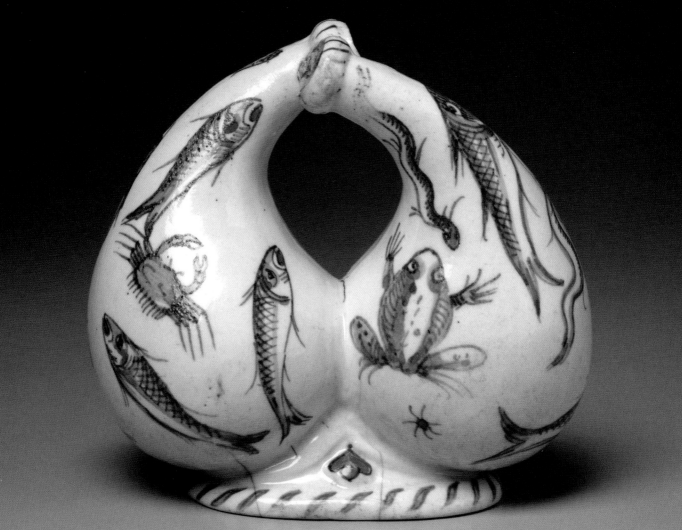

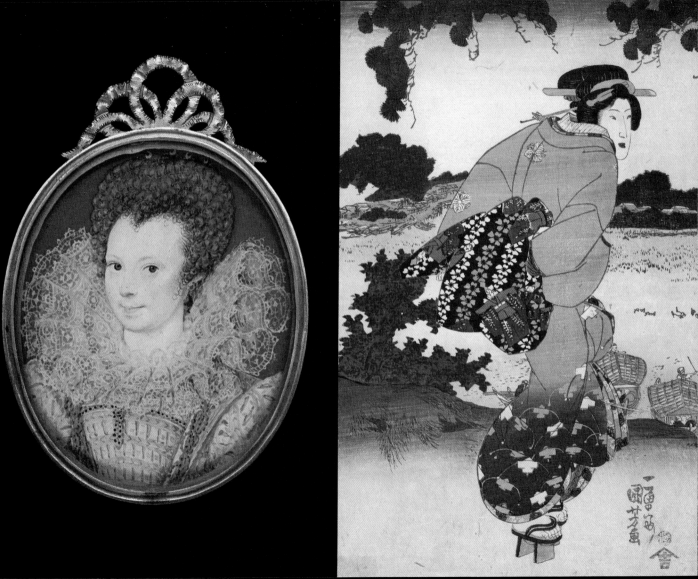

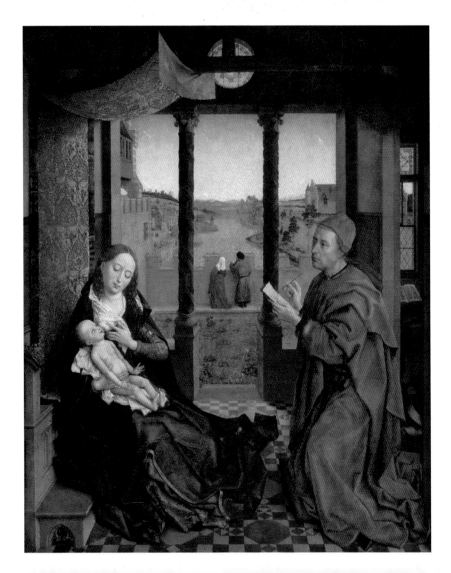

ROGIER VAN DER WEYDEN *Saint Luke Drawing the Virgin*, ca. 1435–1440

UTAGAWA KUNIYOSHI *Favorite Customs of the Present Day (Tōsei fūzoku kō)*, 1830s

NICHOLAS HILLIARD *Portrait of a Lady*, ca. 1590–95

The Brilliant Kingfisher

Yvonne Markowitz

Rita J. Kaplan and Susan B. Kaplan Curator of Jewelry

THE EURASIAN KINGFISHER (*Alcedo atthis*) is known for its radiant, iridescent feathers of electric blue. Unlike most birds, whose colorations are pigment-based, the striking hue of the kingfisher is the result of the manner in which light is bent and reflected out, similar to the way a prism breaks white light into rainbow colors. The bird, found along lakes, ponds, and river marshes, has for centuries captured the imagination of artists, some of whom have used its feathers for decorative purposes.

In China, kingfisher plumes were prized and used as early as the Han dynasty (206 BC–AD 220) to decorate wall hangings and bedcovers. Several centuries later, the Tang poet Chen Zi'ang (661–702) noted that the brilliant kingfisher plumage (the Eurasian kingfisher genus *Alcedo* comes from the Greek *halcyon*) was much admired by women for adornment. He wrote:

The halcyon kingfisher nests in the South Sea realm,
Cock and hen in groves of jeweled trees.
How could they know that the thoughts of lovely women
Covet them as highly as yellow gold?

During the Ming (1368–1644) and Qing (1644–1911) dynasties, the feathers were also used in headdresses, especially those worn by noblewomen on ceremonial occasions and brides on their wedding day. Known as *tianzi*, the headdress typically had long tassels and a fringe of pearls or beads that veiled the face (see page 83). It was characterized by a curved front and flat crown and had a latticework armature of iron wire covered by black silk. Numerous decorative elements were attached to the fabric and frame by thin metal wires, including a central blossom with a jadeite center and pink tourmaline petals; butterflies; bats; flowers; and two phoenixes amid stylized waves and clouds composed of dazzling kingfisher feathers. The pink tourmalines, found on many of these headdresses, were imported from Southern California and were a favorite of the last Qing empress dowager. It is estimated that during the first decade of the twentieth century, San Diego County provided imperial China with nearly 120 tons of the gem.

The kingfisher feathers in the headdress were glued onto a thin gilt-metal substrate with fine wire perimeters reminiscent of filigree enameling. Many of the flowers and critters are *en tremblant*—they were attached to the armature by coiled metal strips and would quiver when the wearer moved about, creating a shimmering effect. The pearl fringe incorporates decorative beads and colorful glass pendants whose colors and forms may have had symbolic significance.

By the early twentieth century, small ornaments using kingfisher feathers, such as hair pins, were popular among ladies of lesser rank. As a result, it was not long before demand outstripped supply for these exotic feathers, and the bird, once abundant in China's rivers and marshes, became endangered.

clockwise from top left: LOUIS MUELLER *Superman Belt Buckle*, 1966
UTAGAWA HIROSHIGE I *Kingfisher and Wild Rose*, 1847–52
POSSIBLY ENGLISH *Bishop's Ring*, 18th century

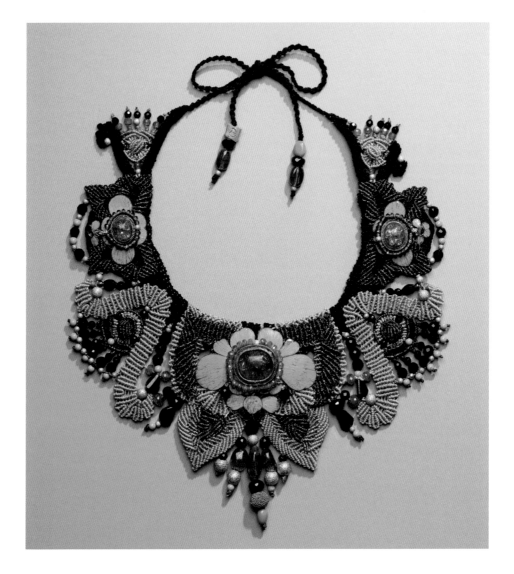

Today, many of these smaller ornaments, as well as fragments of larger, fragile compositions, are sought by collectors. One California jewelry artist, Barbara Natoli Witt, known for her elaborate necklaces composed of fiber and vintage artifacts, acquired a group of kingfisher adornments and created several necklaces designed around them. For Natoli Witt, an artist with a deep appreciation of the cultural context in which jewelry was made and worn, these vibrant ornaments are imbued with meaning. In *Necklace #1536* (2011) (see page 76), gilt-silver peony petals and butterflies with kingfisher inlays serve as potent symbols of prosperity, well-being, and eternal spring. The turquoise macramé echoes the vibrant hue of the feathers, as do the deep pink silk thread and the tourmaline cabochons and beads. The gold, stone, and glass beads add delicacy as well as movement to the ornament in the piece. The spherical beads, which can be found in nearly all of Natoli Witt's necklaces, serve as mandalas, archetypal symbols of unity and wholeness.

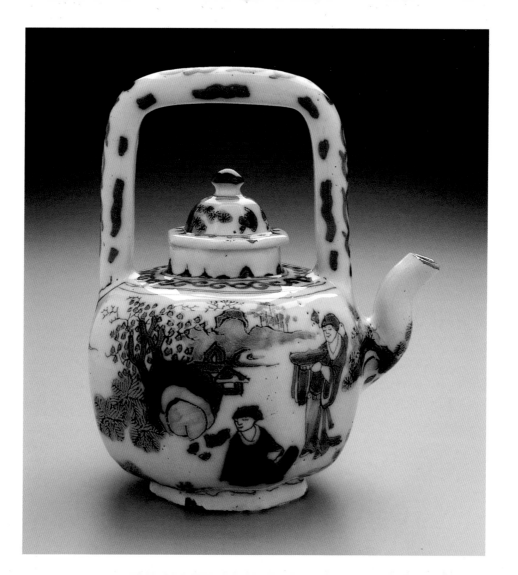

DUTCH *Teapot,* late 17th century

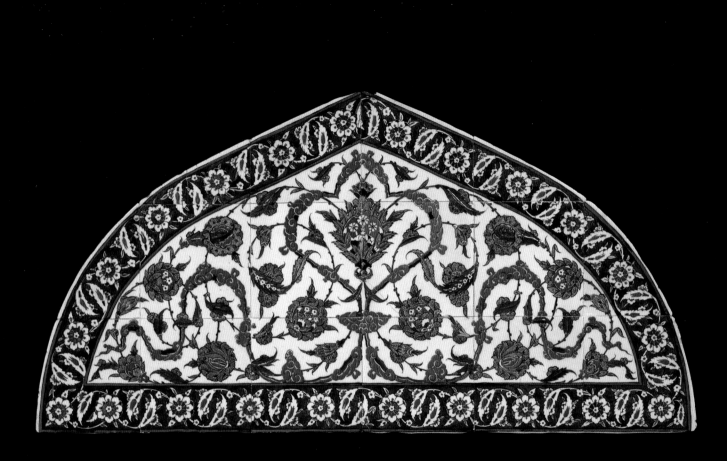

79

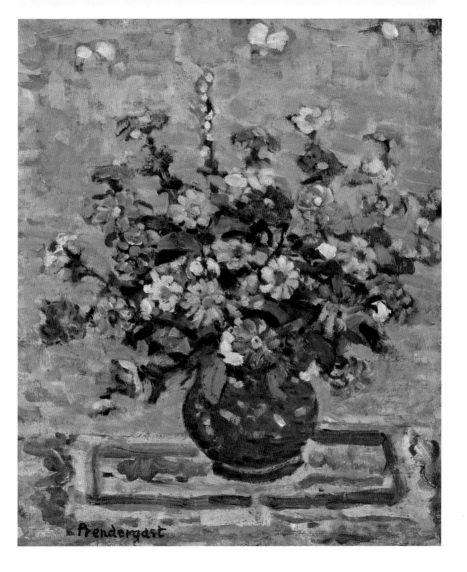

Prendergast

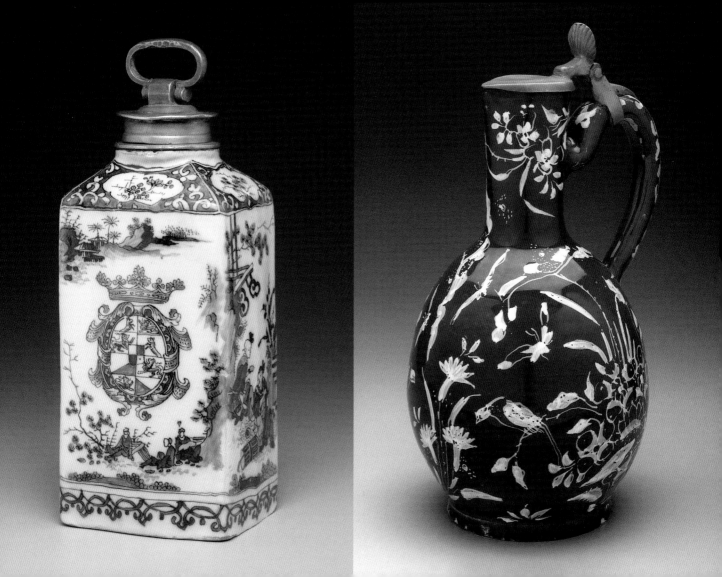

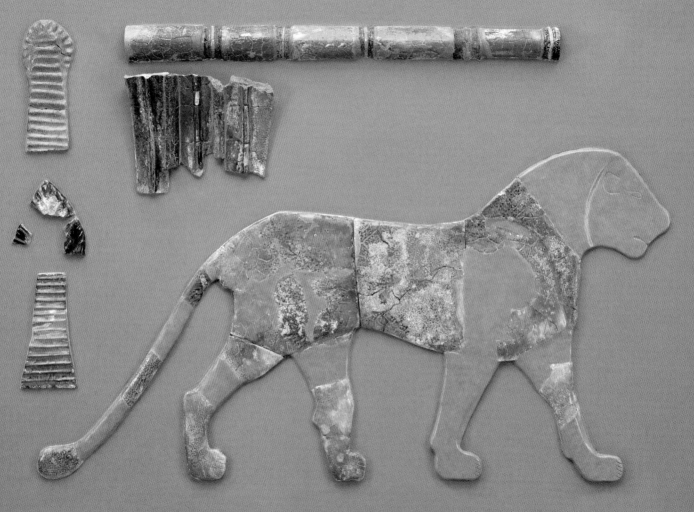

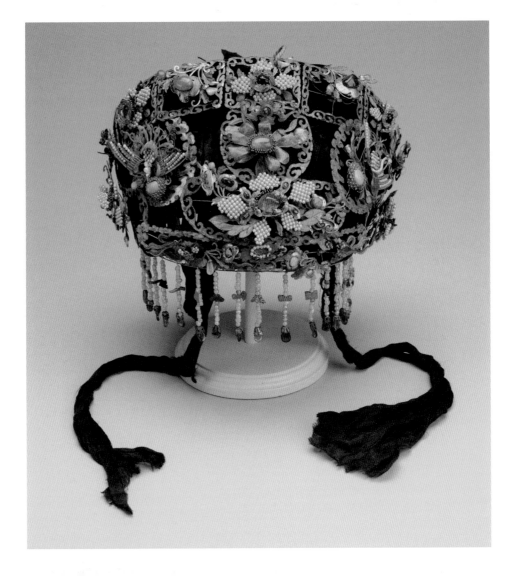

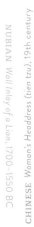

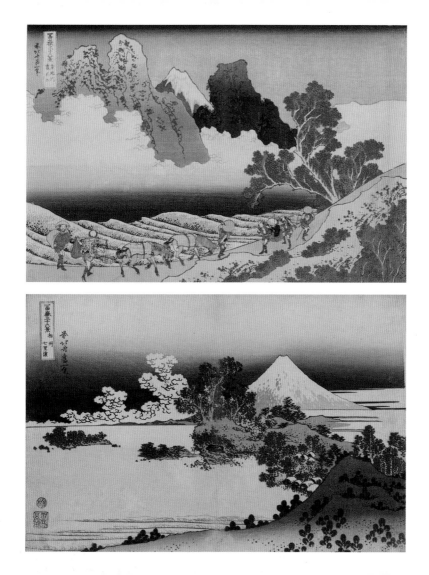

KATSUSHIKA HOKUSAI *Back View of Fuji from the Minobu River (Minobu-gawa ura Fuji);*
Seven-Mile Beach in Sagami Province (Sōshū Shichiri-ga-hama),
both from the series Thirty-Six Views of Mount Fuji (Fugaku sanjūrokkei), ca. 1830–31

TUNISIAN *Leaf of a Qur'an,* 9th or 10th century

Porcelaneous Blue:
The Blue-and-White Tradition in Chinese Porcelain

Nancy Berliner

Wu Tung Curator of Chinese Art

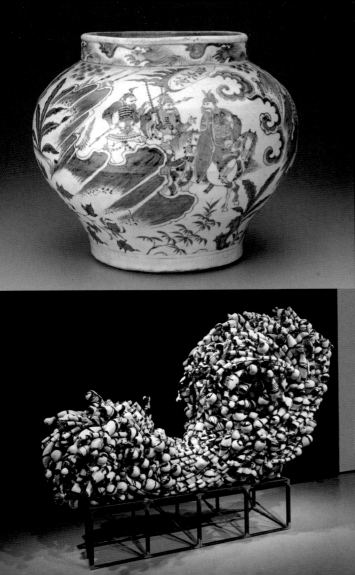

A LIVELY BLUE DRAGON chases a fellow blue creature across the white void, rounding the curve of the bowl and passing bulbous blue clouds on his way (see page 53). Tight circles of blue grapes with their attendant large blue leaves fill the center of a platter, while a blissful blue mandarin duck pair swims among billowing blue lotus leaves on a monumental charger (see page 66). A blue cricket tiptoes toward a blue melon, and blue warriors, hefting high their blue swords, appear from behind brawny blue mountains and forests (see page 87 left top). Thirteenth- and fourteenth-century artisans in China imagined and manifested blissful blue realms, creatures, and patterns to dress the surfaces of white porcelain vessels.

Prior to China's Yuan (1271–1368) dynasty, designs on ceramics were primarily either impressed into the clay or drawn on using brown-black slip. Brushing cobalt-blue imagery onto porcelain and then overlaying those designs with a transparent glaze produced a radically new and rich aesthetic in the Yuan dynasty and generated delight through the Ming (1368–1644) dynasty. In time, this strong blue became the dominant color for limning designs on handsome white porcelains, and blue-and-white porcelain forms became ubiquitous and expected touches in sophisticated rooms and temples throughout China. As knowledge of the technique spread and less-expensive methods for obtaining similar appearances were developed, even modest households could afford the same color palette. Holding flowers, food, drink, incense, and even brushes, blue-and-white porcelain became an icon of Chinese culture around the world.

What gave rise to the visually striking blossoming of blue-and-white porcelain? And why blue? Interestingly, early impetus for the blue-and-white ware most probably came from far beyond China's borders. Blue had been a favored color for ceramics in Babylonia as early as the sixth century BC, when potters were already producing blue-glazed stoneware. The region also held great deposits of cobalt, the primary material needed for generating a full blue color when fired on porcelain. Enamored of the lustrous white porcelain the Chinese were creating in the fourteenth century but unable to produce this special high-fired product themselves, the Persians—descendants of the Babylonians—began importing and commissioning blue-and-white porcelain pieces from China. Today, one of the largest collections of Yuan blue-and-white porcelain is, remarkably, in Iran. Soon, cobalt blue, with its implications of exoticism, expense, and status, was luring Chinese clients as well.

The early blue-and-white imperial porcelain wares of the Yuan—and then of later dynasties—were produced in kilns located in Jingdezhen, Jiangxi Province, with cobalt that was increasingly imported into China from Western Asia. Kaolin, a soft, white clay, one of the main ingredients of fine porcelain, is found in the Jingdezhen area, and so the industry grew up in this town that is still today the national center of porcelain production. The earliest known dated

CHINESE Guan-Type Jar with Lion's-Head Handles, mid-14th century
FELICITY AYLIEFF Five Storeys—Chinese Ladders II, 2009

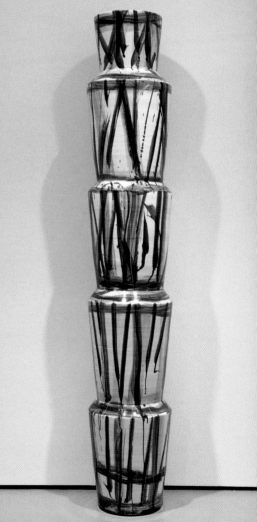

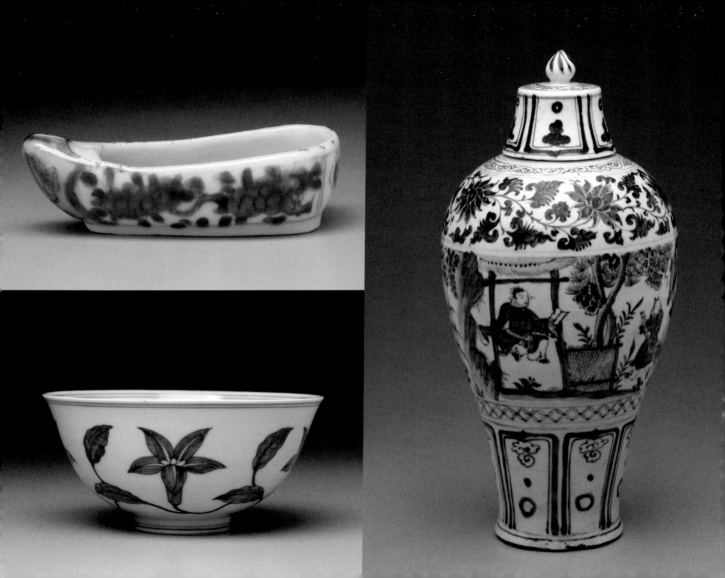

blue-and-white porcelain is a pair of vases (now at the British Museum from the Percival David collection) with an inscription noting that they were being donated to a Daoist temple in the year 1351. The sophistication of the technique and the design on these vases are testimony to the art having already been developed by the mid-fourteenth century.

The striking appearance of the blue-and-white porcelain aesthetic came to enchant the eyes of people in many lands. Numerous shipwrecks, archaeological excavations, and storehouses of centuries-old collections evidence the massive exporting of this finery to Japan, Southeast Asia, central Asia, western Asia, and eventually to Europe (where seventeenth-century Dutch paintings often featured Chinese blue-and-white porcelain to denote luxury) and America. Many of these countries then fabricated their own imitations or homages—Delft ware in the Netherlands (page 14), Willow pattern china in England, Arita ware in Japan (page 87), as well as contemporary creations in China and around the globe today (page 89).

clockwise from top left: CHINESE *Wine Cup in the Shape of a Shoe, second quarter of the 17th century*
Covered Meiping-Shaped Vase with Blue-and-White Decoration of Theatrical Figures, mid-14th century
Bowl with Blue-and-White Decoration of Flower Scrolls, 1465–87

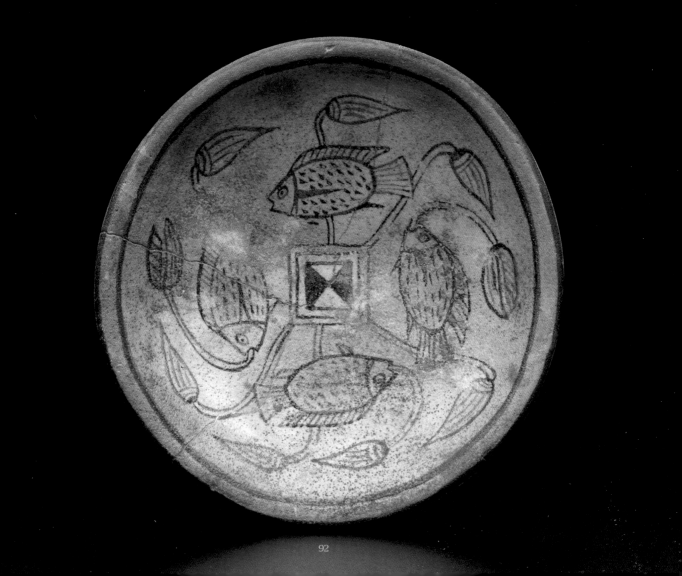

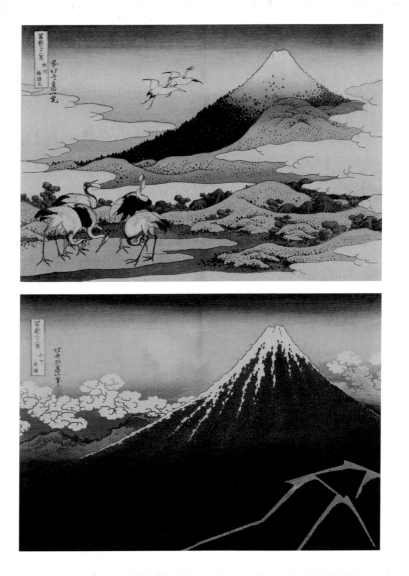

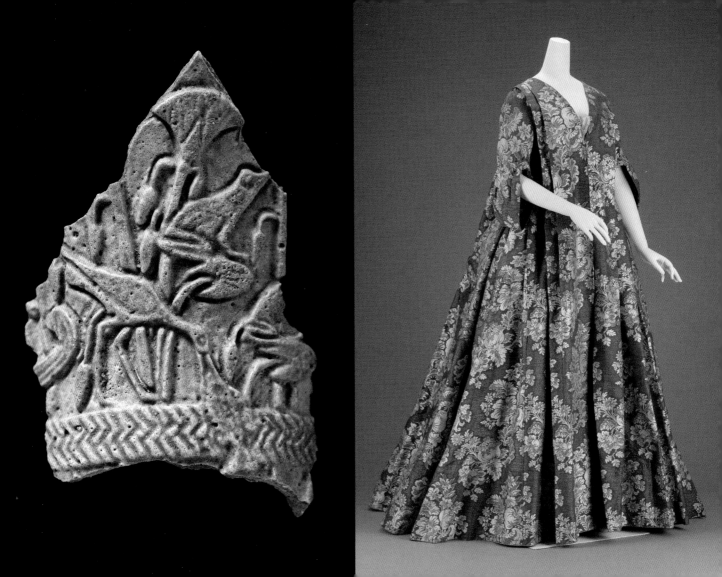

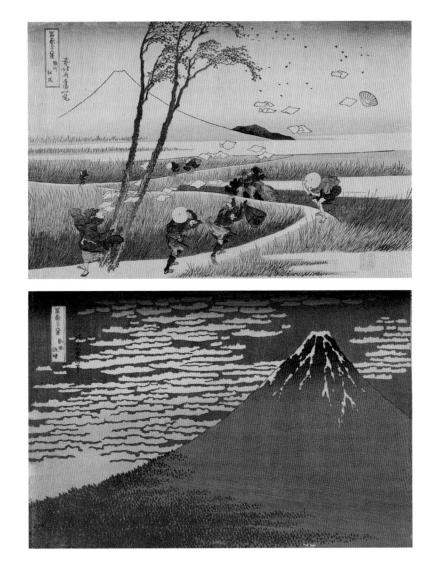

KATSUSHIKA HOKUSAI *Ejiri in Suruga Province (Sunshū Ejiri);*
Fine Wind, Clear Weather (Gaifū kaisei), also known as Red Fuji,
both from the series Thirty-Six Views of Mount Fuji (Fugaku sanjūrokkei), ca. 1830–31

JOHN BROADWOOD & SON *Grand Piano, 1796*

The Rise of Blue in Europe

Rhona MacBeth

Eijk and Rose-Marie van Otterloo Conservator of Paintings

Head of Paintings Conservation

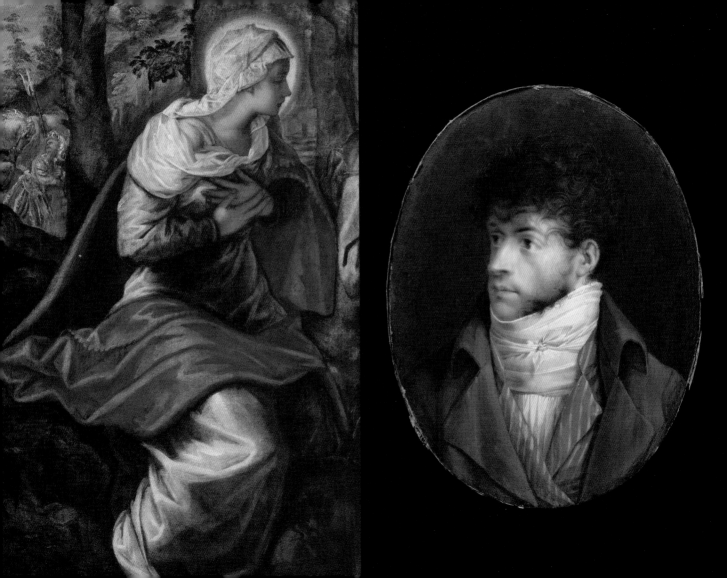

CAN YOU PICTURE A WORLD without the color blue? It's hard to imagine. We live in a color-saturated, blue-centric realm. The importance of blue is fundamental to the way we see and understand the world around us. Just think of the ubiquity of today's blue jeans or the enduring popularity of the Impressionist painters' blue skies.

This was not always the case. In ancient Europe, blue barely registered as a color of consequence. Think of the earliest cave paintings: Black, red, and brown come to mind, all colors readily made from earth and fire. Blue would prove far more difficult to harness. And although blue pigments certainly existed in the ancient world (the mineral azurite being the most common), they weren't easy to use or strong in color.

In early Christianity, red was the dominant color. For example, medieval church calendars would highlight saints' days in red; hence the term "red-letter days." But in the Middle Ages, more reliable ways were found to capture blue, and the hue began to appear more frequently, perhaps most notably in the twelfth-century stained-glass windows of European cathedrals. At the same time, a high-quality intensely blue pigment began to be imported into Europe. This was a vivid blue colorant made from the semiprecious stone lapis lazuli, then found only in remote areas of Afghanistan and Persia. Imported to Europe by sea, it acquired the name ultramarine, and it was a game-changer: When ground and made into paint, it could produce an extraordinarily beautiful purple-blue never seen before in European paintings (see page 140).

The advent of ultramarine coincided with the increasing popularity of the cult of the Virgin, when numerous paintings were commissioned in her honor. As the mother of the crucified Christ, Mary was traditionally portrayed wearing dark colors. But now her somber dress began to shift consistently to blue (see page 169). And when it could be procured, the rare blue of ultramarine would be used, a color more expensive than the highest-quality scarlet and more valuable even than gold (see pages 9 and 71).

Blue was on the ascent. European royalty began to claim the color that had become so closely associated with Christianity (see page 105). The king of France was the first, when in the twelfth century he adopted a new coat of arms, with a field of blue and gold fleurs-de-lis, or stylized lilies associated with the Virgin (see page 105).

Blue also benefited from its close association with black. Seen by the church as a morally superior color, black's popularity in dress escalated with the arrival of high-quality black cloth. In fifteenth- and sixteenth-century portraiture, nobles were frequently depicted in black, or dark, costume, often set against a brilliant blue background (see pages 70 and 106). Slowly, blue, particularly dark blue, inherited black's mantle and was embraced not only as a royal color (see page 139) but also as a sober and virtuous one.

During this same time, another development aided blue's rise to prominence: Oil began to replace egg as the dominant binder in paints. The brilliance of ultramarine, however, became more subdued when mixed with oil, so painters responded by adjusting their technique. By

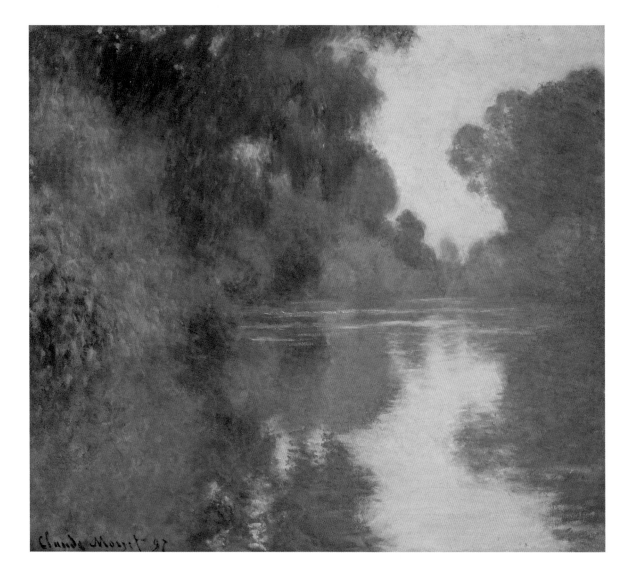

adding white, artists were able to develop a much wider range of blue tones than before, resulting in an enhanced ability to portray the world around them. Soon, a painter's skill in rendering light and surface became more valuable than the inherent cost of their materials. Nowhere do you see this more clearly than in the work of the sixteenth-century Venetian painters Titian and Tintoretto, where color creates form and gives life to flesh (see page 101).

Science also played a crucial role in blue's continued ascent. In 1672, Sir Isaac Newton published his scientific work on light. In separating white light into its component colors and placing blue at its core, he fundamentally changed the way we understand the world around us: The ancient colors of red and yellow were permanently joined by the newcomer—blue (see page 108).

Blue's status as a color of consequence was now irrevocable. But even though its status was accepted by the church, by royalty, and by men of science, the deep purple-blue of ultramarine remained a luxury item for painters. The search for a cheaper blue continued, particularly as demand was growing for larger and larger canvases (see page 56). Painters had a few more choices by the seventeenth century. In addition to stalwart azurite, there was also blue verditer, a copper-based blue pigment, and smalt, a by-product of glassmaking (see page 156). Even the cloth dye indigo was used in painting (see page 58, "Indigo" essay, by Pamela Parmal). But none of these colorants were as stable, would tint as strongly, or were as beautiful as ultramarine.

A breakthrough was made in Germany at the beginning of the eighteenth century, with the accidental discovery of a deep blue pigment we now call Prussian blue (see page 26). A century later, a vibrant, although still expensive, blue mineral-based pigment, cobalt blue, was created. A brilliant, almost dazzling color, it was beloved of the Post Impressionist painters, particularly van Gogh (see page 151). And then, only twenty years later, a French color manufacturer figured out how to make an artificial ultramarine for a fraction of the price of the pigment made from the naturally occuring stone lapis lazuli (see pages 51 and 101). Whether you envision a Monet landscape (see page 103), a Renoir dance (see page 40), or a van Gogh sky (see page 20), their paintings are unimaginable without this new range of affordable and accessible blues (see page 124).

Blue had triumphed. It became the most popular color in Europe, and it remains so today.

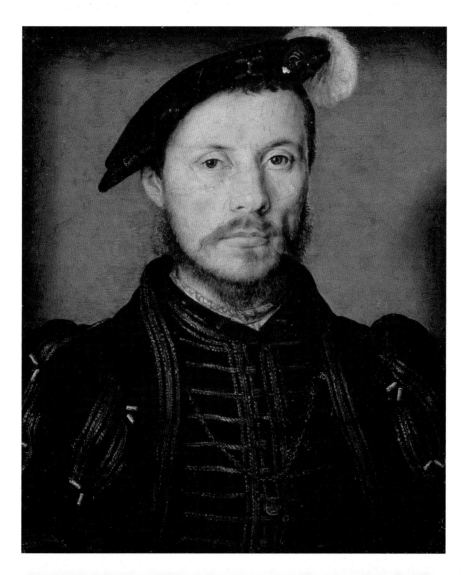

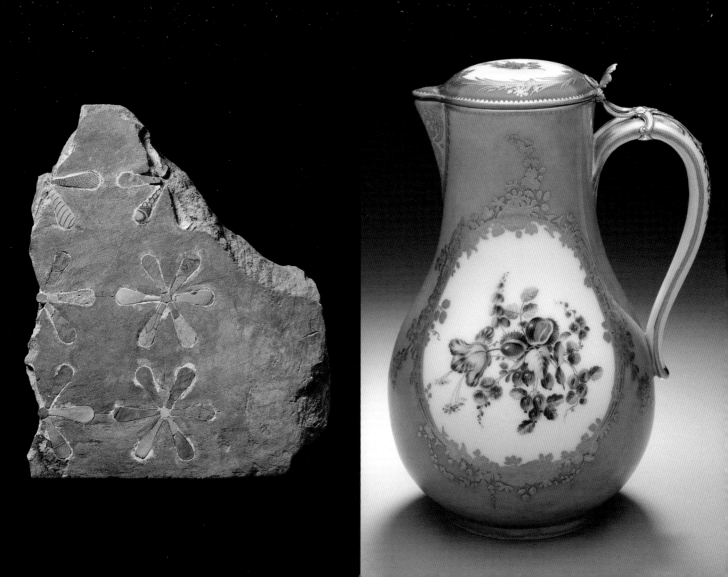

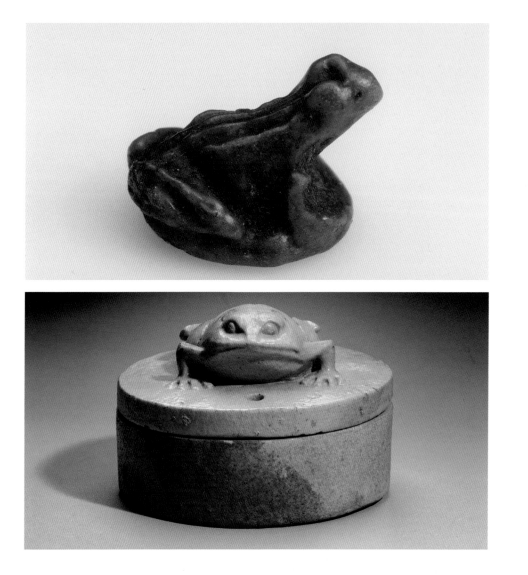

EGYPTIAN *Eye of Horus (Wedjat) Amulet*, 1550–1070 BC
EGYPTIAN *Amulet of a Frog*, 1550–1070 BC
EAST GREEK *Cosmetic Box with Frog*, 600–500 BC

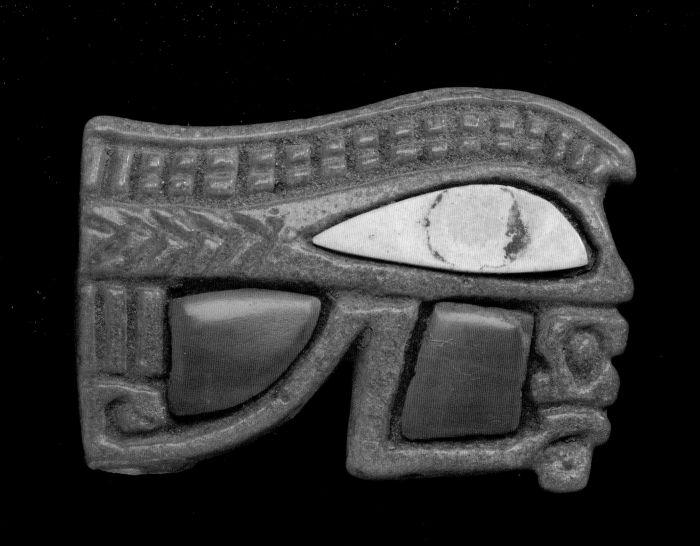

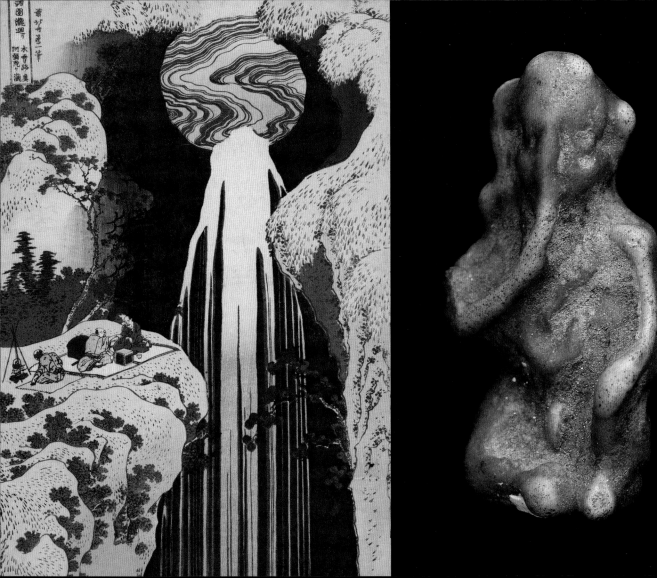

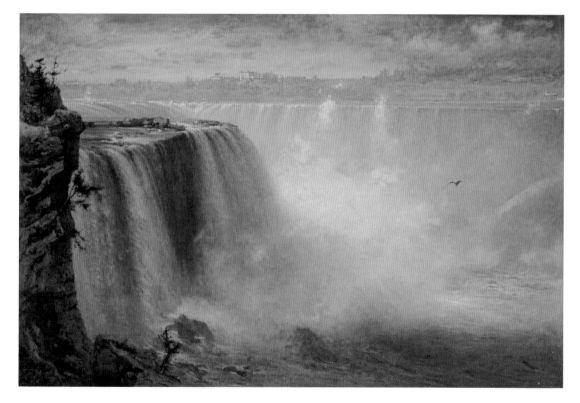

KATSUSHIKA HOKUSAI *The Amida Falls in the Far Reaches of the Kisokaidō Road (Kisoji no oku Amida-ga-taki),*
from the series *A Tour of Waterfalls in Various Provinces (Shokoku taki meguri),* ca. 1832

EGYPTIAN *Amulet of Harpokrates,* 1070–332 BC

GEORGE INNESS *Blue Niagara,* 1884

A Blue Plate Special: Five Centuries of Blue in European Ceramics, 1500 to Today

Thomas Michie

Russell B. and Andrée Beauchamp Stearns Senior Curator of Decorative Arts and Sculpture

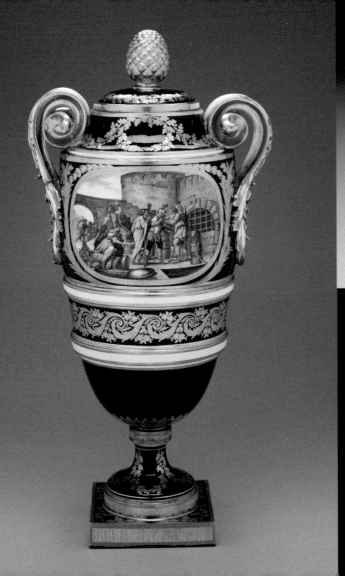
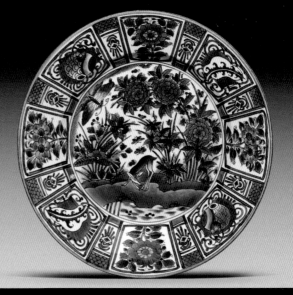

THE NEVER-ENDING POPULARITY of the color blue in European ceramics is inseparable from Europe's age-old quest for true porcelain, a translucent material whose secret was known only to the Chinese for a thousand years, until chemists at the court of Augustus the Strong in Dresden in 1710 discovered the formula for a clay body that would convert to a glassy substance when fired at high temperatures. And as the Chinese knew, and Europeans soon learned, cobalt blue decoration derived from cobalt oxide was the most stable pigment when fired at the high temperatures (1200 to 1350°C) required to produce porcelain. Thus the cross-cultural taste for blue-and-white ceramic decoration was inextricably linked with Europe's early fascination with Chinese porcelain and subsequent efforts to emulate it.

One of the first successful European imitations of Chinese porcelain was developed at the Medici court in Florence. There, under the patronage of Grand Duke Francesco I de' Medici (1541–1587), an artificial porcelain, known as soft-paste porcelain, was perfected during the short-lived operation of the Medici factory between 1575 and 1587. Of the approximately sixty-five surviving examples of Medici porcelain known today, nearly all have blue underglaze decoration, such as the cruet for oil and vinegar (see page 69) decorated with animated fish, frogs, crabs, eels, and insects.

Even after Europeans discovered the secret of true porcelain, less costly earthenware imitations made of common clay and fired at lower temperatures were produced in great quantities throughout the near East and Europe. During the sixteenth, seventeenth, and eighteenth centuries, global trade ensured that blue-and-white ceramics were shipped and exchanged far and wide. Examples of blue-and-white porcelain as well as imitations in every kind of ceramic—porcelain, earthenware, and stoneware—made in China, Japan, Persia, Portugal, Italy, Germany, England, and the Netherlands (see pages 14, 19, 115, 117, 121, 128, and 171) all attest to the impact of Chinese ceramics made for export and reveal the ways different cultures adapted the blue-and-white tradition.

In the seventeenth century, French potters at Nevers developed a particularly rich, dark glaze color known as Persian blue (see pages 67 and 81) in imitation of Turkish ceramics, which in turn had been inspired by Chinese models. The distinctive white-on-blue decoration of these ceramics is the opposite of the more typical blue-on-white. The fashion was popular in England, too, and Persian blue ware continued in production there throughout the seventeenth and eighteenth centuries (see page 67).

In the Netherlands in the mid-seventeenth century, the city of Delft became the center of Dutch pottery production, as dozens of factories (many in former breweries with colorful names) perfected an opaque white glaze using tin oxide, which, when decorated with brilliant blue and fired a second time with a clear lead overglaze, was nearly indistinguishable at first glance from Chinese blue-and-white

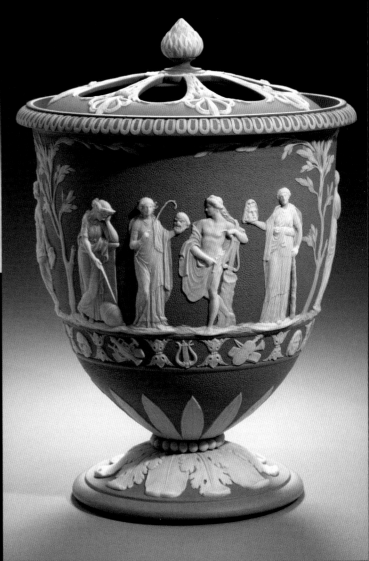

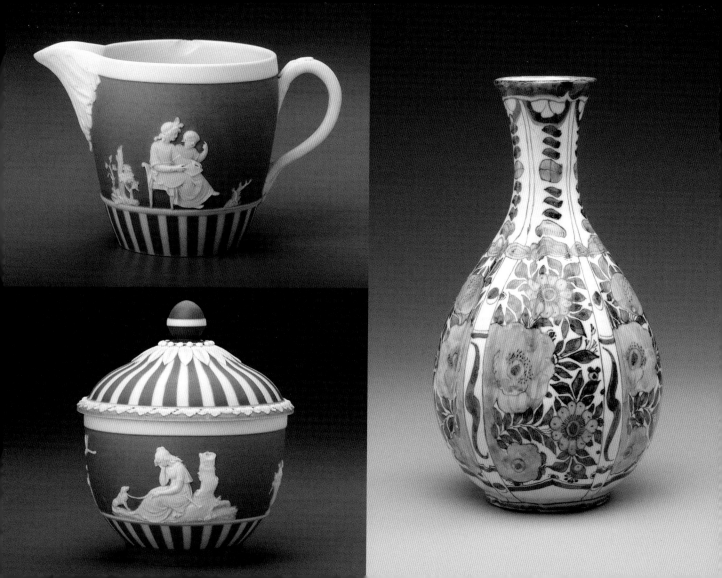

porcelain. Some shapes, such as wine pots (see page 78), sweetmeat sets (see page 115), and gourd-shaped bottles (see page 141), were closely copied from Chinese and Persian examples, while other shapes, such as gin bottles (see page 81) and tulip vases (see page 13), are uniquely Dutch. By the end of the seventeenth century, Delft pottery set the standard for European earthenware.

In early-eighteenth-century France, the Vincennes ceramic factory near Paris developed a soft-paste porcelain that captured the attention of Louis XV and his mistress, Madame de Pompadour. In 1753, the king became the principal investor in the factory, which relocated that year from makeshift quarters in the royal chateau at Vincennes to a new, purpose-built factory at Sèvres. Under the direction of chemist Jean Hellot, Vincennes developed a brilliant new turquoise-blue glaze color that was used for the first time for a large dinner service made for Louis XV (see page 7). Popularly known as *bleu celeste* (sky blue), it is famous for its intensity, and its association with the king assured its popularity (see pages 24, 107, 142, and 166). Sèvres was one of the few European porcelain manufacturers that did not pretend to copy Asian forms or decoration. Pale imitations of *bleu celeste* produced in England suggest the challenges faced by Sèvres's early competitors (see page 152). Porcelain production is generally only as successful as the chemists who oversee the composition of the clay body, ground colors, and glazes. The intense turquoise-blue pigment of early Vincennes and Sèvres porcelain was derived from aquamarine, a gemstone said to have been imported from Venice. Later in the 1750s, Sèvres introduced much deeper blue glaze colors called *bleu lapis*, *bleu nouveau*, or *beau bleu* (see pages 115 and 121) with pigments derived from cobalt oxide.

One of the greatest innovations in English ceramics was Josiah Wedgwood's development in the 1770s of matte stoneware that he called jasper, which he created by staining white clay with metal oxides to produce different colors. At first, the clays were saturated with stain to produce a solid color throughout. Later, production involved dipping the pieces in the stain so that the color rested only on the surface of the clay. Proclaiming that "elegant simplicity" was his goal, Wedgwood's blue jasper with molded and applied decoration in white became synonymous with Neoclassical taste at the end of the eighteenth century (see pages 36, 117, 118 left top and bottom, and 126). French imitations in bisque ware, or unglazed porcelain, and less costly English imitations in earthenware (see page 173) suggest the long-lasting impact of Wedgwood blue jasperware, which has remained in production ever since. For example, glass produced in Vienna around 1907 for the Wiener Werkstätte (Vienna Workshops), a group committed to creating modern, functional decorative arts for urban settings, relies on crisp geometry and the contrast of blue and clear glass (see page 95), much like Wedgwood's Neoclassical designs.

clockwise from top left: ENGLISH *Cream Jug, 1785–90*
DUTCH *"Kraak" Bottle, ca. 1660–80*
ENGLISH *Sugar Bowl, 1785–90*

A generation after the invention of Wedgwood's blue jasper, transfer-printed earthenware was mass-produced in vast quantities by dozens of Staffordshire potteries. For example, the Blue Willow pattern has been in continuous production for nearly two centuries and has even served as a point of departure for contemporary ceramic artists, such as Robert Dawson. Some pieces of the darkest blue earthenware ever produced in England (see page 117) were probably factory seconds relegated to the American market, judging from the quantities found in North America and its rarity in England. Ironically, the saturation of blue almost completely obscures the transfer-printed decoration imagery that was the plate's primary attraction.

clockwise from left: **FRENCH** *Potpourri Vase*, ca. 1785–90
PORTUGUESE *"Kraak" Plate*, 17th century
ENGLISH *Plate*, ca. 1780

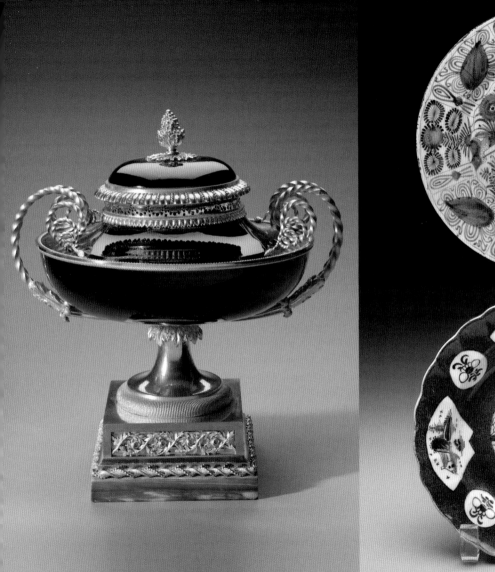

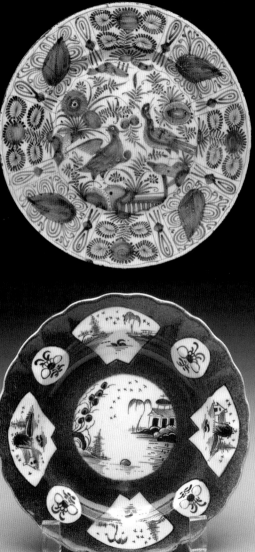

EGYPTIAN *Bowl with Cows*, 1075–656 BC

PAUL CÉZANNE *Fruit and a Jug on a Table*, ca. 1890–94

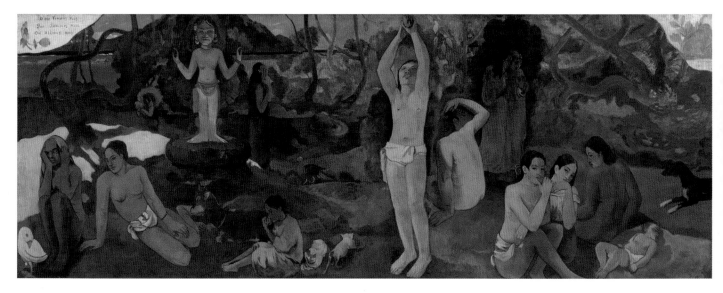

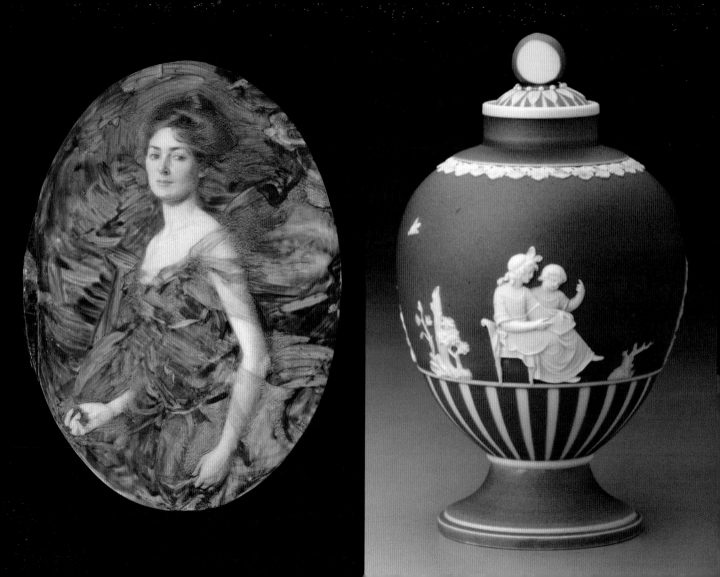

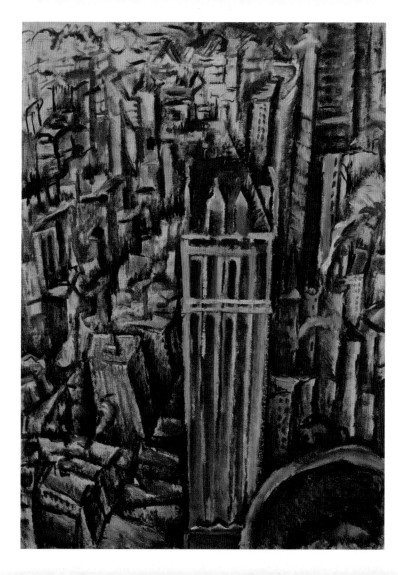

MAX WEBER *New York (The Liberty Tower from the Singer Building)*, 1912

ENGLISH *Tea Canister*, ca. 1785–90
LAURA COOMBS HILLS *The Nymph*, 1908

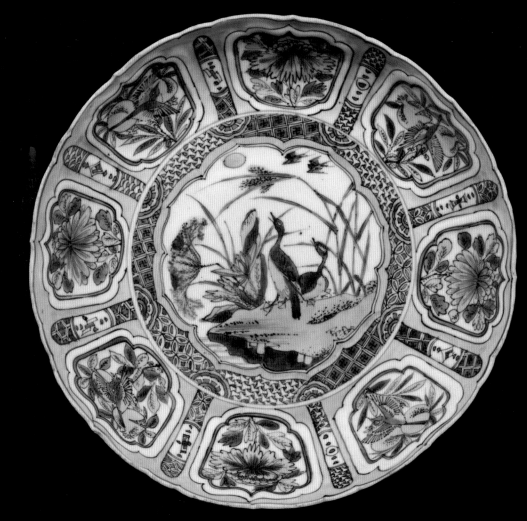

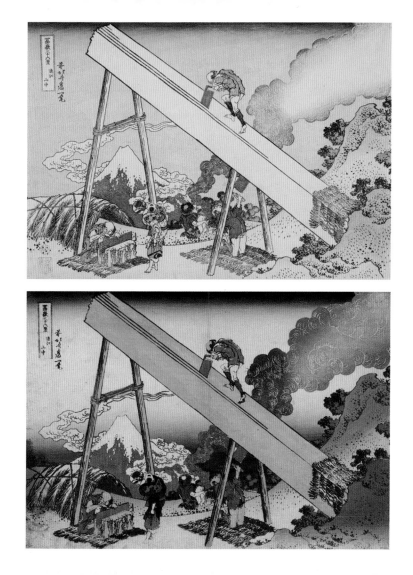

CHINESE EXPORT *Plate*, 1573–1610

KATSUSHIKA HOKUSAI *In the Mountains of Tōtōmi Province (Tōtōmi sanchū)*;
both from the series Thirty-Six Views of Mount Fuji (Fugaku sanjūrokkei), ca. 1830–31.
The first printing uses blue outlines. A later printing of the original uses black outlines and a full range of colors.

The Blues of the Japanese Landscape: Hokusai's Prints of Mount Fuji

Sarah Thompson

Assistant Curator for Japanese Prints

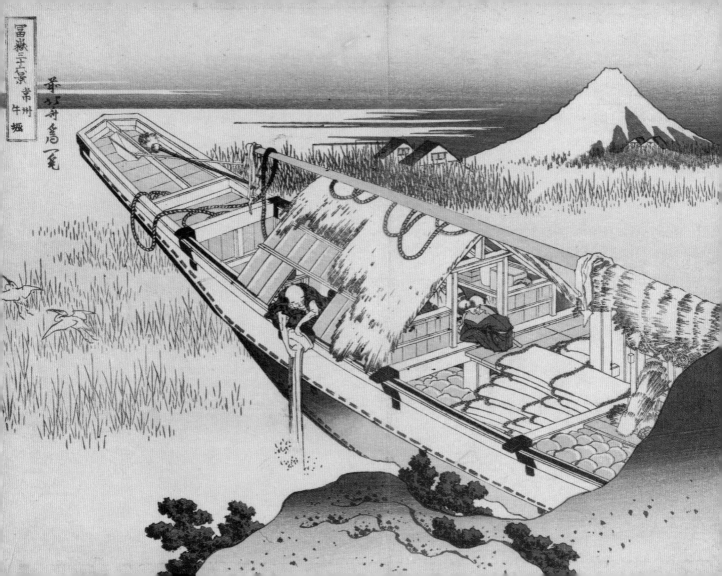

ONE OF THE MOST FAMOUS IMAGES in all of world art is the magnificent color woodblock print designed by Katsushika Hokusai (1760–1849) *Under the Wave off Kanagawa*, often called by its nickname, *The Great Wave* (see page 133). Published around 1830, the print was one of a series depicting Japan's sacred mountain, Thirty-Six Views of Mount Fuji, which also included such powerful images as *Fine Wind, Clear Weather* (nicknamed *The Red Fuji*) (see page 99) and *Rainstorm Beneath the Summit* (see page 94), as well as humorous scenes such as the barrel-maker of *Fuji View Plain in Owari Province* (see page 168 bottom). The Fuji series revolutionized printmaking in Japan, and it made landscape, previously a minor subject for prints, into a major genre for the first time. Customers flocked to the publisher's bookstore to buy each new design as it was issued.

The Fuji series is remarkable not only for its masterful compositions but for its extensive use of shades of blue. Even the basic outlines of the forms, usually printed in black ink, are rendered in dark blue in the earliest editions of the first thirty-six of the series of forty-six prints. (Ten extra designs were added to the planned series, probably at the request of the publisher, Nishimuraya Yohachi, because the prints were selling so well.) The wave in *Under the Wave off Kanagawa* includes four different colors within its blue outlines: dark, medium, and light tones of blue, with the white of the unprinted paper making up a fourth "color." The outlines are printed with traditional indigo,

but the colors of the wave itself are done in a pigment new to the Japanese print world, the synthetic European pigment known in the West as Prussian blue and called Berlin blue in Japan. Invented in Europe in the early eighteenth century, the pigment was brought to Japan by Dutch traders, the only Europeans allowed into Japan at that time. In the 1820s, it began to be imported by the Chinese as well as the Dutch, and the price dropped sufficiently to make it practical for use in the inexpensive woodblock prints intended for an ordinary audience.

Full-color printing, using five or more separate woodblocks to print the colors, had been practiced in Japan on a large-scale commercial basis since 1765. The pigment most often used for blue was a vegetable color derived from the petals of the dayflower (*Commelina communis*, known as *tsuyugusa* in Japan). Dayflower blue produced a beautiful clear, light blue color, but unfortunately it faded very quickly. Few eighteenth-century prints have survived with their original colors intact. Indigo, another vegetable color, was also used in printing, but it tended to produce matte, grayish blues rather than bright ones. Brilliant mineral colors such as azurite were used in Japanese painting to produce gorgeous blues, but they did not work well for printing because of the large size of the particles and, in any case, were too expensive for a popular art form like woodblock prints. Given the disadvantages of the existing pigments, Berlin blue was a most welcome addition to the printer's palette.

KATSUSHIKA HOKUSAI *Under the Wave off Kanagawa (Kanagawa-oki nami-ura)*, also known as *The Great Wave*, from the series Thirty-Six Views of Mount Fuji (Fugaku sanjūrokkei), ca. 1830–31

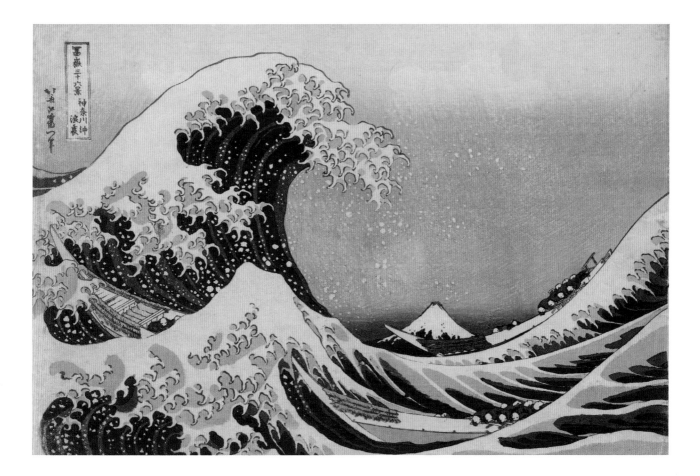

The first mass-produced prints using the new colorant were designs done entirely or almost entirely in blue, intended to be cut out and pasted on flat bamboo fans. In 1829 and 1830, the blue fans became a fashionable accessory that harmonized beautifully with the indigo-dyed cotton kimono (*yukata*) worn by both females and males during the hot, humid Japanese summer. The appeal of pictures in cool-looking shades of blue was already familiar to the Japanese through decorations on blue-and-white porcelain, and now, at last, such pictures were available in an inexpensive, take-along form.

Either Hokusai or his publisher must have realized that the new pigment used for the popular fan prints was the answer to the problem of creating landscape prints that would have lasting appeal to customers. A publisher's advertisement in the back of a book printed at the end of 1830 announces a series of scenes of Mount Fuji by Hokusai, printed in blue (*aizuri*) and including views of the mountain from such places as Tsukudajima (see page 136) and Shichirigahama (see page 85).

There are various scholarly arguments regarding the order in which the prints of the Fuji series were issued. But today, it is generally thought that the very first were the five designs whose first editions are, except for the red marks indicating the publisher and the censor's seal of approval, entirely in blue (see pages 85, 131, 135 top, 136, and 168 top), followed by five with faint traces of other colors such as green or gray (see pages 65, 94 top, 99 top, 129 top, and 135 bottom). In the next group of designs in the series,

such as *Under the Wave*, Hokusai used a broader range of colors with the new blues smoothly integrated (see pages 99 bottom, 133, and 168 bottom). Finally, in the ten "extra" prints at the end of the series, black outlines were used once again, but with Berlin blue still prominent among the colors (see page 85 top). The first prints of the series, originally printed largely in blue tones, were reprinted in full color in later printings (see page 129 bottom).

Hokusai and other artists of the early 1830s also designed "blue-printed pictures" (*aizuri-e*) of genre scenes (see page 38 right), nature subjects (see page 192), fashionably dressed women (see page 70 right), and even kabuki actors. He used the blue-outline technique for one additional landscape series, the vertical *Waterfalls*, which show falling water in eight different configurations (see page 112 left). The *Waterfalls* prints are in full color, but the blue outlines emphasize the importance of water as the main subject of each design.

The color blue had a wide range of symbolic meanings for both Hokusai and his viewers. When he designed the Mount Fuji series, Hokusai was in his sixties. He had completed one full cycle of the sixty-year East Asian astrological calendar and was beginning a new phase of his life. So for him, blue could have been a symbol of spirituality and rebirth. It also implied the wider world of which the Japanese city-dwellers, who eagerly bought the prints, were becoming increasingly aware—both the countryside of Japan itself, and the world beyond the sea that would interact decisively with Japan just a few decades later.

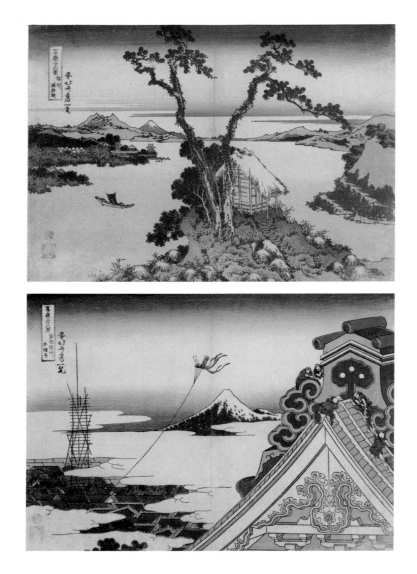

KATSUSHIKA HOKUSAI *Lake Suwa in Shinano Province (Shinshū Suwako);*
Hongan-ji Temple at Asakusa in Edo (Tōto Asakusa hongan-ji),
both from the series Thirty-Six Views of Mount Fuji (Fugaku sanjūrokkei), ca. 1830–31

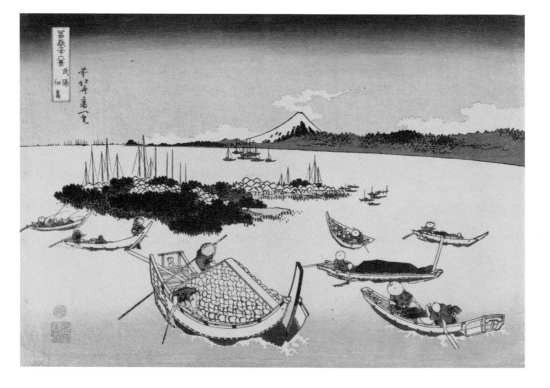

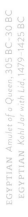

KATSUSHIKA HOKUSAI *Tsukudajima in Musashi Province (Buyō Tsukudajima),* from the series Thirty-Six Views of Mount Fuji *(Fugaku sanjūrokkei),* ca. 1830–31

EGYPTIAN *Amulet of a Queen,* 305 BC–30 BC
EGYPTIAN *Kohl Jar with Lid,* 1479–1425 BC

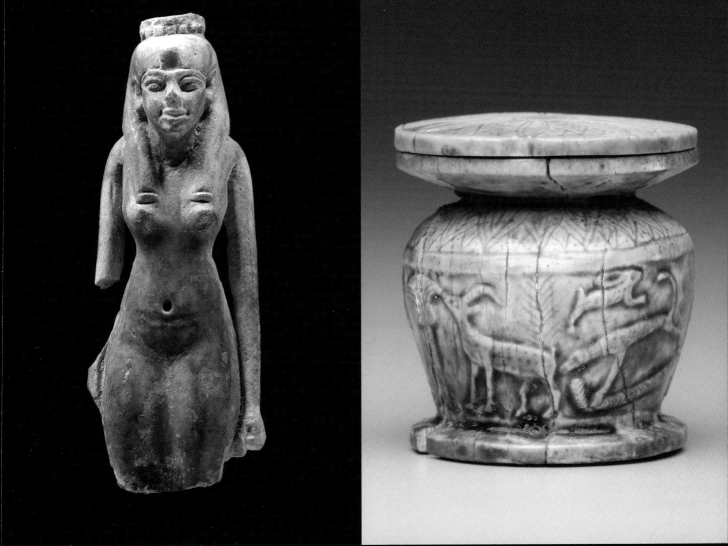

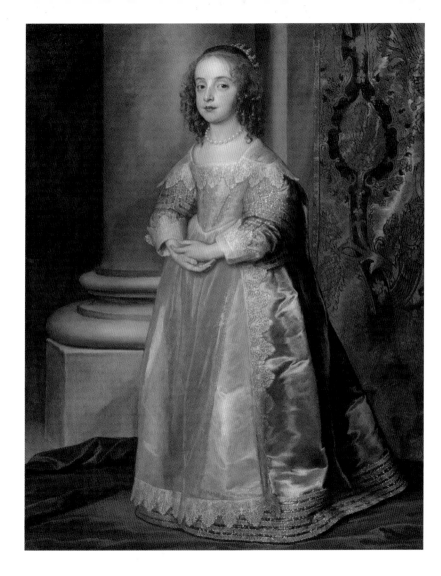

ANTHONY VAN DYCK *Princess Mary, Daughter of Charles I,* ca.1637

NUBIAN *Amulet of Isis and Horus,* AD 20–90

EGYPTIAN *Jug (oinochoe),* 30 BC–AD 364

FRA ANGELICO *Virgin and Child Enthroned with Saints Peter, Paul and George (?), Four Angels, and a Donor,* ca. 1446–49

DUTCH *Pair of Double Gourd–Shaped Bottles,* ca. 1686–92

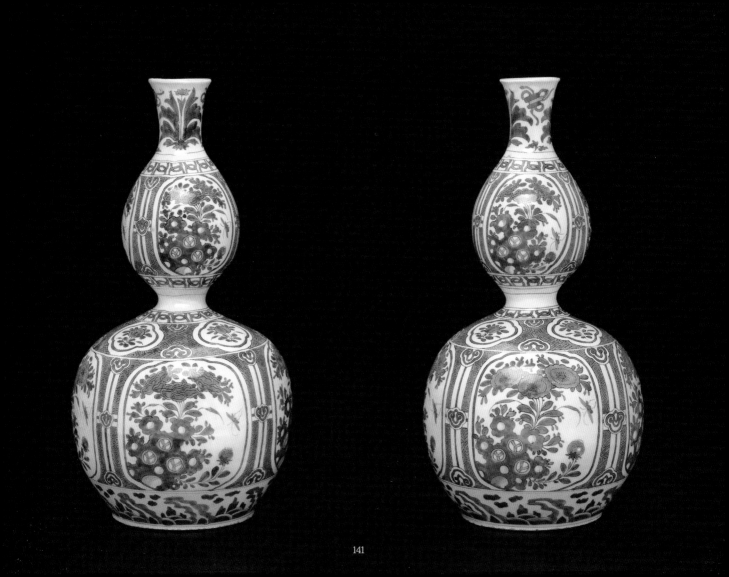

141

濱田富

Cyanotype Photography

Anne E. Havinga

Estrellita and Yousuf Karsh Senior Curator of Photographs

U. S. Steamlaunch "Louise".
1885.

ONE OF THE EARLIEST PHOTOGRAPHIC processes is the cyanotype, invented in 1842 by Sir John Herschel. Fascinated by the new medium of photography, the British astronomer and chemist found himself drawn to investigating its possibilities. He solved the problem of finding a fixing agent to stabilize photographic prints (the so-called hypo) and coined the terms *negative* and *positive* for the field. He then discovered a process by which he could make color photographs on paper in great detail but only in the shade of blue. The invention was based on the reaction of certain iron salts to light, and he named it the *cyanotype* (after the Greek *cyan*, meaning "deep blue"). One of the advantages of the process was its simplicity: Only a few chemicals plus water and sunlight were needed to yield visions of startling beauty.

Anna Atkins, daughter of a friend of Herschel's, was among the first to use the process. A botanist, she initially made cyanotypes from pieces of seaweed that she dried, laid on the sensitized paper, and exposed to light. Since her prints involved no negative, they were unique. She compiled them into what was the first photographically illustrated book, *British Algae: Cyanotype Impressions*, issued in sections from 1843 to 1853. Atkins went on to record a number of other specimens, especially ferns and flowering plants (see page 150). While privately published in a limited number of copies, her photographs combine artful beauty and serious science.

Henry Peter Bosse took a similar approach when he used the process several decades later. Employed as a draughtsman for the U.S. Army Corps of Engineers, Bosse was enlisted from 1882 to 1892 to draw scenes of the Mississippi River, and the alterations that the corps made to it, from St. Paul to St. Louis. In addition to drawn depictions, he exposed over three hundred negatives, thoroughly recording the water's shores, ships, and bridges (see page 145). The cyanotype had just started to become a standard in mapmaking and architectural firms (for "blueprints"), so he was familiar with it. Contact printing his images as ovals, he assembled them in albums titled *Views on the Mississippi River between Minneapolis, Minn. and St. Louis, Mo. 1883–1891*. Bosse's work offered a picturesque documentary record of Mark Twain's famous river.

The decorative simplicity of the cyanotype made it popular among artists of the Arts and Crafts movement around 1900. One of these was Arthur Wesley Dow, an influential painter and printmaker who was fascinated with Japanese art and design and who—through his teaching and his book *Composition* (1899)—helped establish key elements of modernism for American art. In his art, Dow specialized in poetic views in and around his hometown of Ipswich, Massachusetts. He found the cyanotype particularly appealing for its bright color and because it resembled the indigo present in many Japanese prints (see page 149). His talent for creating images of playful geometry is apparent in these compositions.

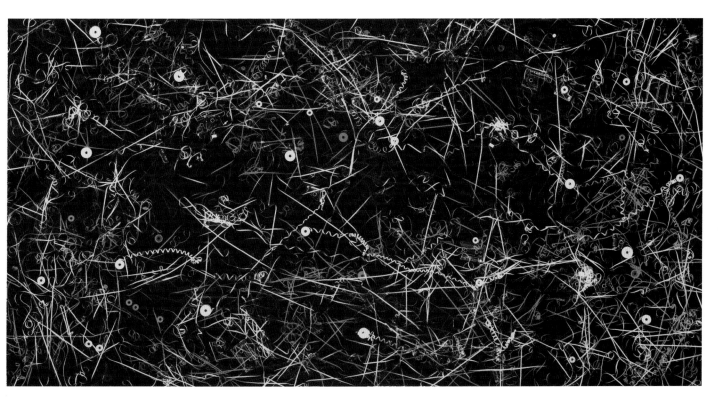

A revival of interest in the cyanotype has arisen in recent years, especially among artists fascinated by antiquated photographic practice. The Swiss-American artist Christian Marclay is known for creating visual connections between popular music and traditional art media. He was invited to work at the University of South Florida Graphicstudio from 2008 to 2009, where he made a series of oversize cyanotypes with old cassette tapes. He chose to unwind the tapes and "draw" with them, laying their tangles on the photosensitized paper (see page 147). These abstractions can be interpreted as both lyrical visions and evocations of silent, "unraveled" song. For Marclay—as it had been for Atkins, Bosse, and Dow—the cyanotype, with its arbitrary, decorative, and intense hue, was a perfect tool for combining accurate representation and poetic metaphor.

ARTHUR WESLEY DOW *Salt Marsh, ca.* 1904

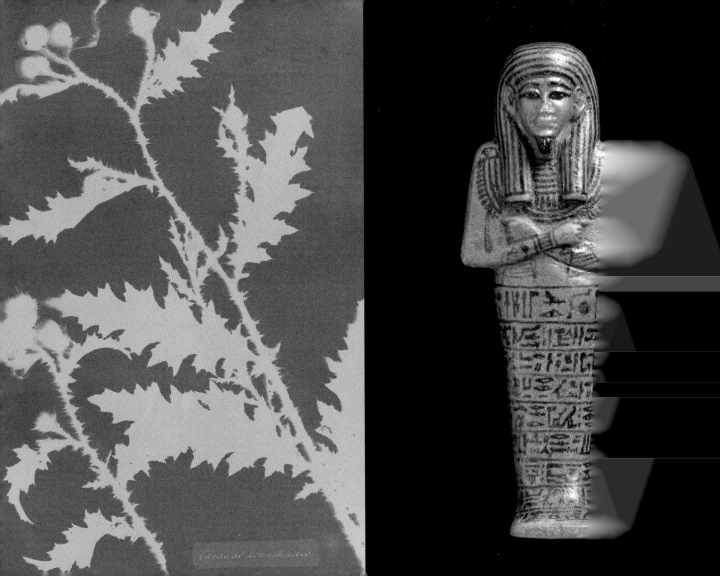

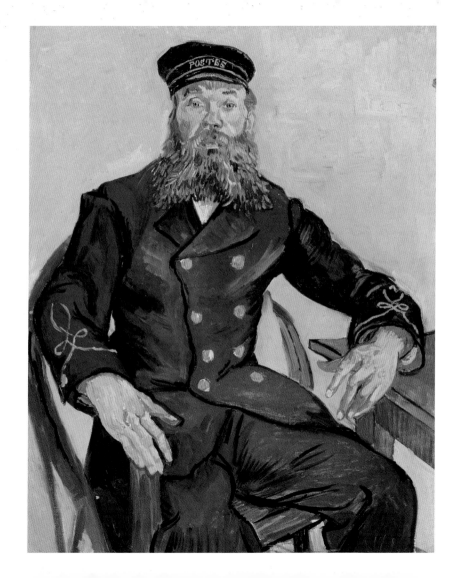

VINCENT VAN GOGH *Postman Joseph Roulin*, 1888

EGYPTIAN *Shawabti of the Priest of Sekhmet Huy*, 1550–1213 BC
ANNA ATKINS *Thistle (Carduus acanthoides)*, 1851–54

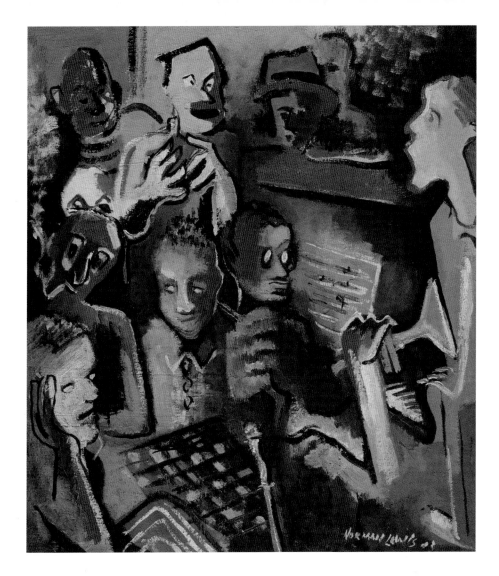

NORMAN LEWIS *Harlem Jazz Jamboree,* 1943

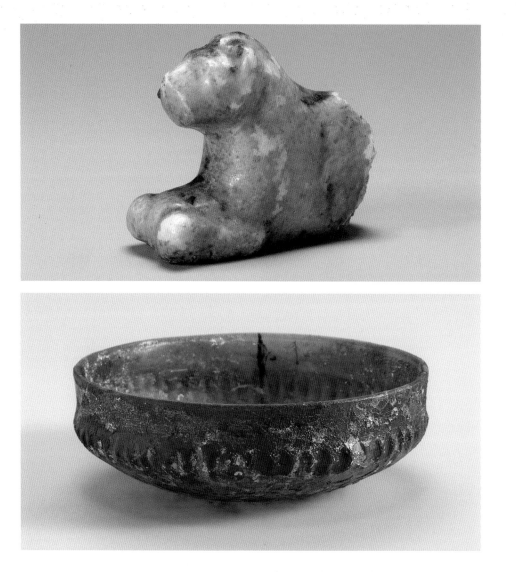

NUBIAN *Forepart of a Reclining Lion*, ca. 1700–1550 BC
ROMAN *Cast Rib Blue Bowl*, 1st century BC–AD 1st century

ELSA FREUND *Space Pendant with Circlet*, ca. 1960

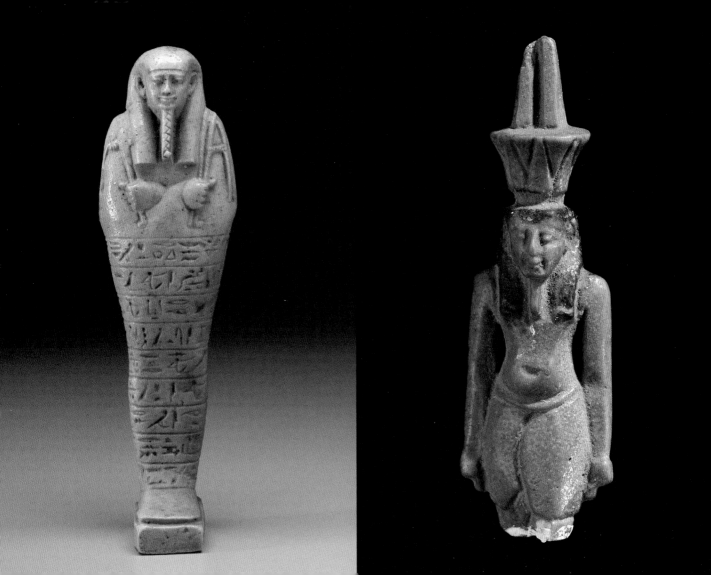

The Blues

Caroline Cole

Ellyn McColgan Assistant Curator, Decorative Arts and Sculpture, Art of Americas

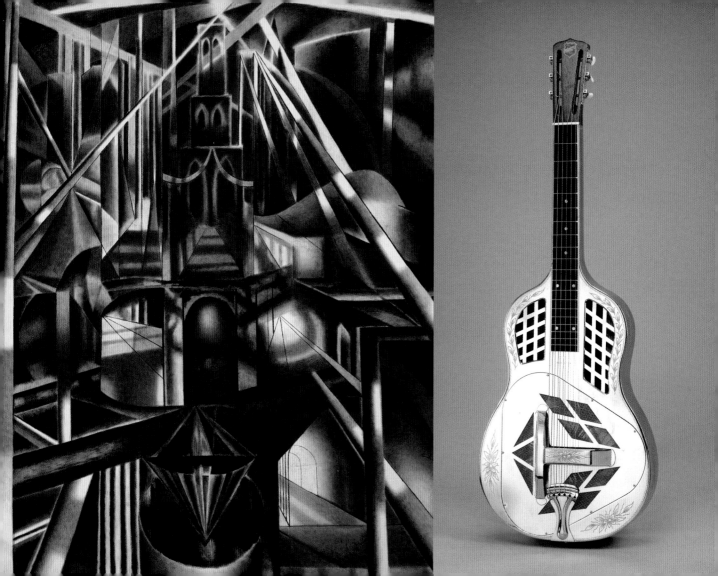

IN THE POPULAR CULTURE of the United States, *the blues* bears specific meaning—a morose spirit whose origins are as mixed and mysterious as the power that the color invokes. As a sound, style, mood, and tone, the blues is a cornerstone of the American music tradition, and one of the most important contributions to the nation's cultural identity of the twentieth century. The color blue is inextricably linked to the story of American modern art through blues music and the mood that it conjures, as well as the use of blue in painting and design. Blue is a color that resonates.

But how did this uniquely American art form come to be known as the blues? The color blue can be mysterious; it is associated with water and sky—elements that are immense and without limits. The association of blue with the depressed or downtrodden is shared by many cultures. Linguists note the use of the expression *the blue devils* by Europeans as early as the eighteenth century to describe the state of agitation following alcohol withdrawal. Over time, that meaning came to be understood as melancholy or sadness. The color has long held mournful associations for West African cultures who used deep blue dye from the indigo plant for mourning ceremonies. Beginning in the late seventeenth century, this connection moved with West African slaves to the plantation farms of the Deep South, where they cultivated the indigo plant and put their sorrows to music.

As a term for a genre of American music that developed in the southern United States, *the blues* was in use by the early twentieth century. Largely inspired by the hymns, ballads, and spirituals of African Americans, the blues developed as a foundation for many of the major music and stylistic movements of the modern era. Starting in the mid-nineteenth century, blues music was popular entertainment for urban audiences. A hybrid style, the blues was closely associated with jazz music, which had its heyday in the 1920s and '30s; the rhythm and blues tradition of the 1940s; and the rock and roll of the 1950s. A resonator guitar from 1934 (see page 159) uses aluminum discs to amplify its bright twang, the distinctive sound of the blues.

Artists used the color blue to capture the tone of American Modernism. Norman Lewis, an artist living in the 1930s in the center of the Harlem jazz world, portrays the energy and vibrant personalities that populated jazz clubs through vivid colors, bold brushstrokes, and expressive facial features and gestures. *Harlem Jazz Jamboree* (1943) (see page 153) is a syncopation of hot reds and cool blues that harmonize with the sounds and improvisational riffs of jazz music. The New York City skyline, recognized as a symbol of modernity, was an inexhaustible inspiration for artists in the early twentieth century. Max Weber, a Russian-born painter, plays with Cubist principles of scale and presence in his *New York (The Liberty Tower from the Singer Building)* (1912) (see page 127), where the single blue

Attributed to: BOSTON AND SANDWICH GLASS COMPANY
Paneled Door from Roswell Gleason House, ca. 1845–60
LOUIS F. VAUPEL *Goblet*, ca. 1860–75

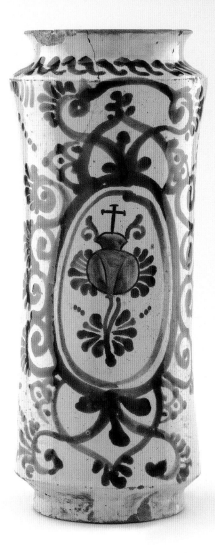

pillar stands out against the vast and energized urban backdrop. The high notes of these bright city blues cool to low, sonorous blue tones in Modernist Joseph Stella's *Old Brooklyn Bridge* (ca. 1941) (see page 159).

Blues music evolved as part of the story of modern American versatility, incorporating diverse cultural traditions into something universally understood. From Memphis blues to the ziggurat lines of the New York City skyline, to the ubiquitous denim blue jeans, blue has colored the history of American art and design.

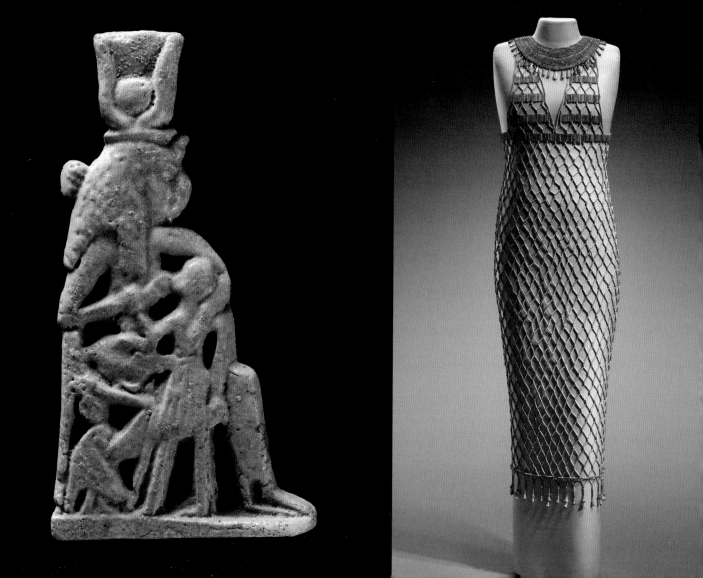

TOMIE NAGANO *Quilt: Katazome Indigo Cotton, from the series Two Hearts in Harmony,* 2000

EGYPTIAN *Beadnet Dress,* 2551–2528 BC

EGYPTIAN *Amulet of Isis and Horus,* 1550 BC–332 BC

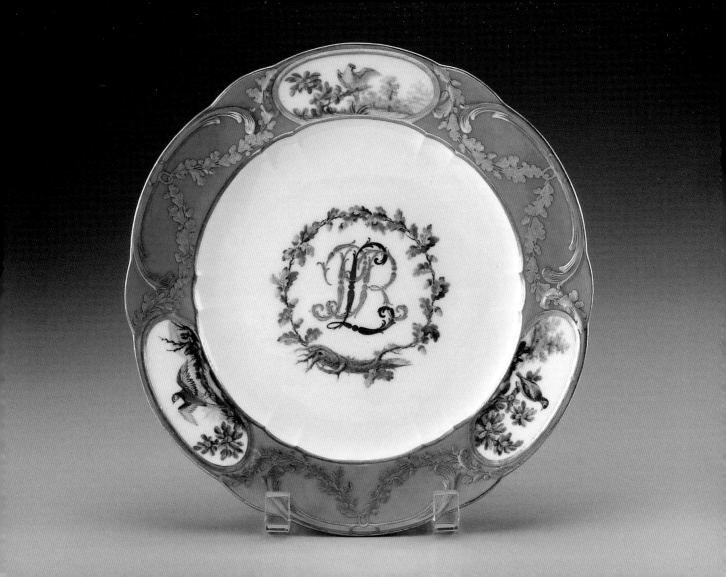

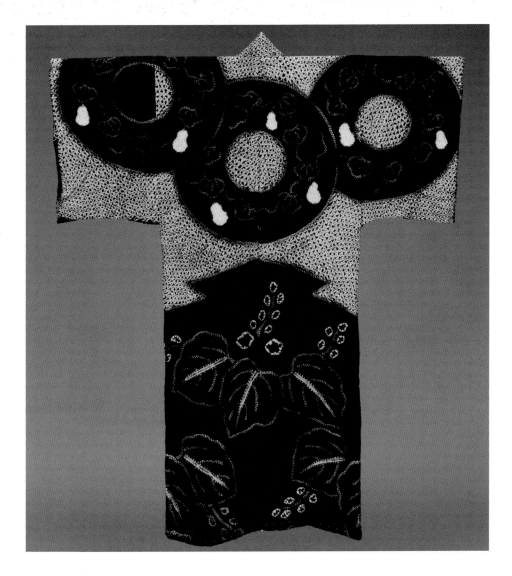

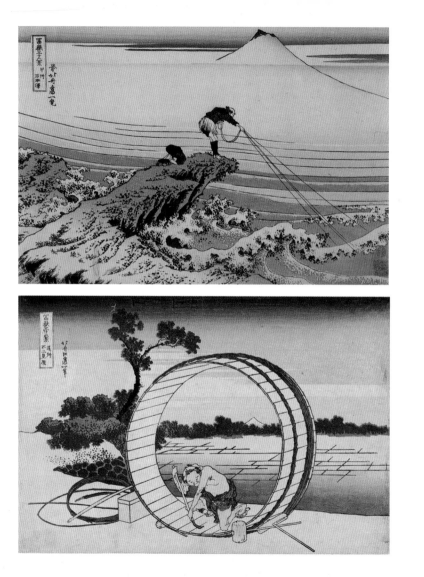

DUCCIO DI BUONINSEGNA AND WORKSHOP *Triptych: The Crucifixion;
the Redeemer with Angels; Saint Nicholas; Saint Gregory,* 1311–18

KATSUSHIKA HOKUSAI *Kajikazawa in Kai Province (Kōshū Kajikazawa);
Fuji View Plain in Owari Province (Bishū Fujimi-ga-hara),*
both from the series Thirty-Six Views of Mount Fuji (Fugaku sanjurokkei), ca. 1830–31

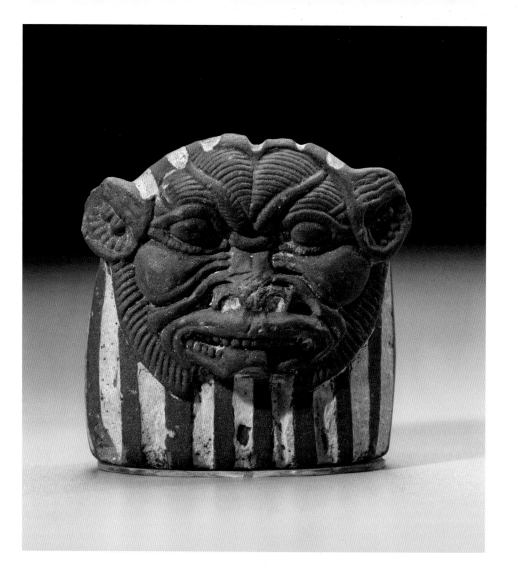

EGYPTIAN *Head of the God Bes, 1390–1353 BC*

ITALIAN *Plate from a Service Made for the Peroli Family of Urbino, ca. 1515–30*

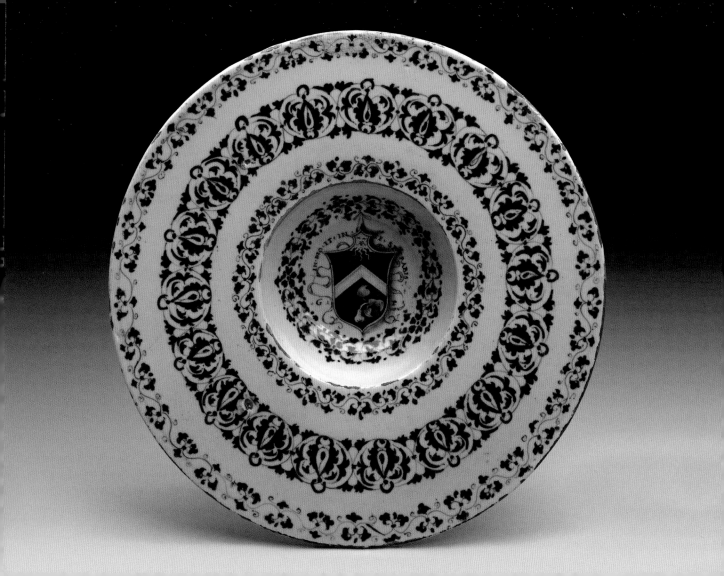

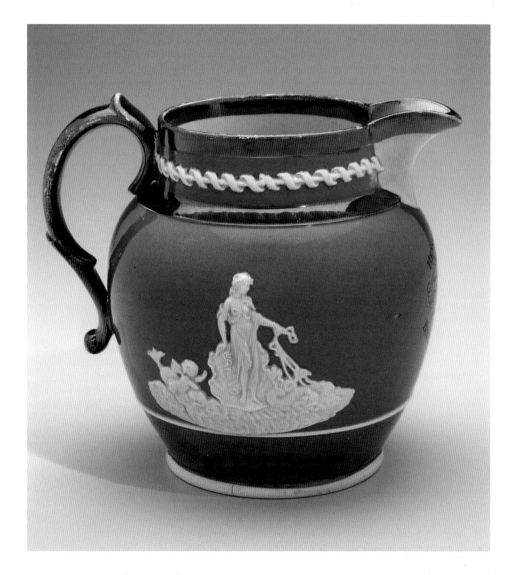

2 × 2 cm (¹³⁄₁₆ × ¹³⁄₁₆ in)
Museum of Fine Arts, Boston
Hay Collection—Gift of C. Granville Way, 72.2875

TITLE PAGE
Damascus, Syria, 17th–18th century
Tile
Fritware, with polychrome decoration under
a transparent glaze
Museum of Fine Arts, Boston
Bequest of Mrs. Francis Jackson Ward, 22.627

TITLE PAGE
Greek, Late Hellenistic Period, 1st century BC
Oil Flask (alabastron)
Glass, cast, gold-band mosaic
13.4 cm (5¼ in)
Museum of Fine Arts, Boston
Henry Lillie Pierce Fund, 98.939

TITLE PAGE
Korean, Joseon dynasty, 17th century
Fan: Cranes and Lotuses
Ink and color on paper
50.8 × 83.8 × 3.8 cm (20 × 33 × 1½ in)
Museum of Fine Arts, Boston
Gift of Robert Treat Paine, Jr., 47.1551

TITLE PAGE
John Singleton Copley, American, 1738–1815
Mrs. Joseph Barrell (Hannah Fitch), ca. 1771
Pastel on paper mounted on canvas
60.64 × 45.72 cm (23⅞ × 18 in)
Museum of Fine Arts, Boston
Gift of Benjamin Joy, 52.1472

PAGE 6
Egyptian, New Kingdom, Dynasty 18,
1539–1295/1292 BC
Eye of Horus (Wedjat) Ring
Faience

PAGE 7
French, 1754–55
Platter from the Louis XV Service
Made at: Vincennes Manufactory, France
Soft-paste porcelain with colored enamels and
gilded decoration
4.3 × 26.7 × 38.7 cm (1¹¹⁄₁₆ × 10½ × 15¼ in)
Museum of Fine Arts, Boston
Anonymous gift, 1992.469

PAGE 8
Egyptian, Old Kingdom, Dynasty 4,
reign of Khufu, 2551–2528 BC
Broad Collar
Findspot: Egypt, Giza, Tomb G 7440 Z
Faience
Museum of Fine Arts, Boston
Harvard University–Boston Museum of Fine Arts
Expedition, 27.1548.2

PAGE 9
Joos van Cleve, Flemish, active in 1522,
died 1540 or 1541
The Crucifixion, ca. 1525
Oil on panel
80.4 × 63.2 cm (31⅝ × 24⅞ in)
Museum of Fine Arts, Boston
The Picture Fund, 12.170

PAGE 10
Charles Sheeler, American, 1883–1965
Three White Tulips, 1912
Oil on panel
34.92 × 26.67 cm (13¾ × 10½ in)
Museum of Fine Arts, Boston
Gift of the William H. Lane Foundation, 1990.442

PAGE 11
Egyptian, New Kingdom, Dynasty 18,
1550–1295 BC
Ibex Finial
Egyptian blue
Height: 5.5 cm (2³⁄₁₆ in)
Museum of Fine Arts, Boston
William Stevenson Smith Fund, 1979.159

PAGE 11
Egyptian, New Kingdom, Dynasty 18, reign of
Thutmose IV, 1400–1390 BC
Model Throw Stick
Findspot: Egypt, Thebes, Valley of the Kings,
Tomb of Thutmose IV, Notes: Egypt (Valley of
the Kings, Tomb of Thutmose IV)
26 × 4.1 cm (10¼ × 1⅝ in)
Museum of Fine Arts, Boston
Gift of Theodore M. Davis, 03.1086

PAGE 12
South Sea Islands, 19th century
Bark Cloth
81 × 102 cm (31⅞ × 40³⁄₁₆ in)
Museum of Fine Arts, Boston
Alfred Greenough Collection, 85.485

PAGE 13
Roman, Late Republican or Imperial Period,
late 1st century BC–AD 1st century
Ribbed Bowl
Mosaic glass, form and decoration of vessel
produced by fusion of small mosaiclike elements—
thin slices of a cane fused into a marbled pattern
4.4 cm (1¾ in)
Museum of Fine Arts, Boston
Henry Lillie Pierce Fund, 99.442

PAGE 13
Dutch (Delft), ca. 1690
Pair of Tulip Vases as Triumphal Arches

Tin-glazed earthenware
Attributed to: Adriaen Kocks, Dutch, Proprietor,
The Greek A Factory, active 1687–1701
29.5 × 30.5 × 7.6 cm (11⅝ × 12 × 3 in)
Museum of Fine Arts, Boston
The G. Ephis Collection—Museum purchase with
funds donated anonymously, Charles Bain Hoyt
Fund, John H. and Ernestine A. Payne Fund, Mary
S. and Edward J. Holmes Fund, William Francis
Warden Fund, Tamara Petrosian Davis Sculpture
Fund, John Lowell Gardner Fund, Seth K. Sweetser
Fund, H. E. Bolles Fund, and funds by exchange
from the Kiyi and Edward M. Pflueger Collection—
Bequest of Edward M. Pflueger and Gift of Kiyi
Powers Pflueger, 2012.605.1–2

PAGE 14
Dutch (Delft), late 17th century
"Kraak" Plate
Marked by: Albrecht Cornelisz Keiser, active
ca. 1667–90
Made by: The Two Ships Factory
Tin-glazed earthenware
39 cm (15⅜ in)
Museum of Fine Arts, Boston
The G. Ephis Collection—Museum purchase with
funds donated anonymously, Charles Bain Hoyt
Fund, John H. and Ernestine A. Payne Fund, Mary
S. and Edward J. Holmes Fund, William Francis
Warden Fund, Tamara Petrosian Davis Sculpture
Fund, John Lowell Gardner Fund, Seth K. Sweetser
Fund, H. E. Bolles Fund, and funds by exchange
from the Kiyi and Edward M. Pflueger Collection—
Bequest of Edward M. Pflueger and Gift of Kiyi
Powers Pflueger, 2012.569

PAGE 15
Léon Nikolaievitch Bakst, Russian, 1866–1924
The High Priest (Costume Design for "Dieu Bleu"), 1911
Opaque and transparent watercolor, silver paint,
and graphite on paper

27.2 × 23.3 cm (10¹¹⁄₁₆ × 9³⁄₁₆ in)
Museum of Fine Arts, Boston
Denman Waldo Ross Collection, 17.594

PAGE 19
Nubian, Classic Kerma, 1700–1550 BC
Body of a Sphinx
Findspot: Nubia (Sudan), Kerma, Tumulus K III
Glazed quartz
33.1 × 43.6 cm (13¹⁄₁₆ × 17³⁄₁₆ in)
Museum of Fine Arts, Boston
Harvard University—Boston Museum of Fine Arts
Expedition, 20.1223

PAGE 19
Persian, Seljuk or Ilkhanid, 13th century
Large Jar
Object Place: probably Kashan, Iran
Composite body (quartz, clay, and glass frit),
molded, with opaque blue glaze
69 cm (27³⁄₁₆ in)
Museum of Fine Arts, Boston
Gift of Edward Jackson Holmes, 44.829

PAGE 19
German, ca. 1700
Dish
Made at: Frankfurt, Germany
Tin-glazed earthenware (faience)
39.4 cm (15½ in)
Museum of Fine Arts, Boston
Kiyi and Edward M. Pflueger Collection.
Bequest of Edward M. Pflueger and Gift of
Kiyi Powers Pflueger, 2006.1136

PAGE 20
Vincent van Gogh, Dutch (worked in France),
1853–1890
Houses at Auvers, 1890
Oil on canvas
75.6 × 61.9 cm (29¾ × 24⅜ in)

Museum of Fine Arts, Boston
Bequest of John T. Spaulding, 48.549

PAGE 21
Nubian, Mid-Classic Kerma, 1700–1600 BC
Necklace with Blue-Glazed Quartz Crystal Pendant
Findspot: Nubia (Sudan), kerma, Tomb K X, South
Cemetery
Glazed quartz
Length: 42 cm (16⁹⁄₁₆ in)
Museum of Fine Arts, Boston
Harvard University—Boston Museum of Fine Arts
Expedition, 13.4128

PAGE 22
French, artist unknown, 18th century
Design for Weaving
Opaque watercolor (gouache) on printed point
(graph) paper
13.3 × 17.4 cm (5³⁄₁₆ × 6¹³⁄₁₆ in)
Museum of Fine Arts, Boston
Maria Antoinette Evans Fund, 30.1474

PAGE 23
Egyptian, Late Period, Dynasty 26, 664–525 BC
Perfume Bottle in the Form of a Trussed Duck or Goose
Faience
2.7 × 3.6 × 7.8 cm (1¹⁄₁₆ × 1⁷⁄₁₆ × 3¹⁄₁₆ in)
Museum of Fine Arts, Boston
Marilyn M. Simpson Fund, 1996.108

PAGE 23
Egyptian, Middle Kingdom, 1991–1640 BC
Hippopotamus Figurine
Findspot: Nubia (Sudan), Kerma, grave 1301/1
Faience
Length: 7.8 cm (3¹⁄₁₆ in)
Museum of Fine Arts, Boston
Harvard University–Boston Museum of Fine Arts
Expedition, 13.4121

PAGE 24

French, 1754–55

Covered Bowl and Stand (Ecuelle Ronde et Plateau à Bord de Relief)

Made at: Vincennes Manufactory, France

Soft-paste porcelain with colored enamel and gilded decoration

15.2 × 21.3 cm (6 × 8⅜ in)

Museum of Fine Arts, Boston

Gift of Rita and Frits Markus, 1980.618a-c

PAGE 25

Boston and Sandwich Glass Company, 1826–1888

Sugar Bowl and Cover, ca. 1830–40

Pressed glass

13.65 cm (5⅜ in)

Museum of Fine Arts, Boston

Gift of Kenneth and Mary Jane Wakefield in memory of Ruth Graves Wakefield, 1979.673

PAGE 26

Canaletto (Giovanni Antonio Canal), Italian (Venetian), 1697–1768

Bacino di San Marco, Venice, ca. 1738

Oil on canvas

124.5 × 204.5 cm (49 × 80½ in)

Museum of Fine Arts, Boston

Abbott Lawrence Fund, Seth K. Sweetser Fund, and Charles Edward French Fund, 39.290

PAGE 27

Egyptian, Late Period, Dynasty 26, 664–525 BC

Cartouche-Shaped Inkwell

Faience

1 × 3.5 × 6.8 cm (⅜ × 1⅜ × 2¹¹⁄₁₆ in)

Museum of Fine Arts, Boston

Egyptian Curator's Fund, 1982.150

PAGE 29

Egyptian, Middle Kingdom–Second Intermediate Period, Dynasty 13–17, 1991–1550 BC

Ointment Jar in the Form of a Trussed Duck

Anhydrite

6.2 × 15 × 7.4 cm (2⁷⁄₁₆ × 5⅞ × 2¹⁵⁄₁₆ in)

Museum of Fine Arts, Boston

Gift of Horace L. Mayer, 65.1749

PAGE 29

Egyptian, Third Intermediate–Hellenistic (Ptolemaic) Period, ca. 1070 BC–30 BC

Amulet of Ra-Horakhty as a Falcon

Faience

5.2 cm (2¹⁄₁₆ in)

Museum of Fine Arts, Boston

Gift of Mrs. Samuel D. Warren, 94.268

PAGE 29

Egyptian, Late Period, Dynasty 25–30, 760–332 BC

Winged Scarab Pectoral

Faience

5.4 × 12.5 × 0.8 cm (2⅛ × 4¹⁵⁄₁₆ × ⁵⁄₁₆ in)

Museum of Fine Arts, Boston

Hay Collection–Gift of C. Granville Way, 72.3024a-c

PAGE 30

Egyptian, New Kingdom, Dynasty 18, reign of Thutmose IV, 1400–1390 BC

Funerary Equipment of Thutmose IV

Findspot: Egypt, Thebes, Valley of the Kings, Tomb of Thutmose IV (KV43)

Faience

Group shot: 03.1086, 03.1089, 03.1103a-c, 03.1098, 03.1096, 03.1095

Museum of Fine Arts, Boston

Gift of Theodore M. Davis

PAGE 33

Egyptian, New Kingdom, Dynasty 18, reign of Thutmose III, 1479–1425 BC

Blue Lotus Chalice

Findspot: Egypt, Abydos, Tomb D 115

Faience

14 × 11 cm (5½ × 4⁵⁄₁₆ in)

Museum of Fine Arts, Boston

Egypt Exploration Fund by subscription, 01.7396

PAGE 33

Egyptian, New Kingdom, Dynasty 18, 1550–1295 BC

Scarab

Findspot: Nubia (Sudan), Semna, S XXX

Steatite

1 × 1.5 cm (⅜ × ⁹⁄₁₆ in)

Museum of Fine Arts, Boston

Harvard University–Boston Museum of Fine Arts Expedition, 24.1528

PAGE 33

Egyptian, Roman Imperial Period, 30 BC–AD 364

Eye of Horus (Wedjat) Amulet

Findspot: Egypt, Giza, communal grave in the Menkaura pyramid temple

Faience

5.2 × 3.5 cm (2¹⁄₁₆ × 1⅜ in)

Museum of Fine Arts, Boston

Harvard University–Boston Museum of Fine Arts Expedition, 11.799

PAGE 34

Egyptian, New Kingdom, Dynasty 18, reign of Thutmose IV, 1400–1390 BC

Shawabti of Thutmose IV

Findspot: Egypt, Thebes, Valley of the Kings, Tomb of Thutmose IV (KV43)

Bichrome faience

17.5 cm (6⅞ in)

Museum of Fine Arts, Boston

Gift of Theodore M. Davis, 03.1100

PAGE 34

Egyptian, Late Period, Dynasty 25, 760–660 BC

Mummy of Nesmutaatneru
Findspot: Egypt, Thebes, Deir el-Bahari, Temple of Hatshepsut
Human remains, linen, faience
151 cm (59⅜ in)
Museum of Fine Arts, Boston
Egypt Exploration Fund by subscription, 95.1407a

PAGE 35
Egyptian, New Kingdom, Dynasty 19–20, 1295–1070 BC
Canopic Jar
Faience
Lid: 8 cm (3⅛ in)
Jar body: 22 × 16.3 cm (8¹¹⁄₁₆ × 6⅜ in)
Museum of Fine Arts, Boston
Gift of Mrs. J. D. Cameron Bradley in memory of her mother, Mrs. J. Montgomery Sears, 48.1286a-b

PAGE 36
English, 1785–90
Teapot
Made at: Wedgwood Manufactory, Staffordshire, England
Colored stoneware (jasperware)
14 × 17.2 × 10.5 cm (5½ × 6¾ × 4⅛ in)
Museum of Fine Arts, Boston
Bequest of George Washington Wales, 03.265a-b

PAGE 37
Winslow Homer, American, 1836–1910
The Blue Boat, 1892
Watercolor over graphite pencil on paper
38.6 × 54.6 cm (15³⁄₁₆ × 21½ in)
Museum of Fine Arts, Boston
William Sturgis Bigelow Collection, 26.764

PAGE 38
Egyptian, Late Period, Dynasty 26, 664–525 BC
Shawabti of Neferseshempsamtik

Faience
18.8 × 5 × 4.2 cm (7⅜ × 1¹⁵⁄₁₆ × 1⅝ in)
Museum of Fine Arts, Boston
Hay Collection—Gift of C. Granville Way, 72.1681

PAGE 38
Katsushika Hokusai, Japanese, 1760–1849
Man Washing Potatoes, from an untitled series of blue (*aizuri*) prints
Japanese, ca. 1831, Edo period (1615–1868)
Woodblock print (*aizuri-e*), color on paper
23.5 × 16.7 cm (9¼ × 6⁹⁄₁₆ in)
Museum of Fine Arts, Boston
William Sturgis Bigelow Collection, 11.20399

PAGE 39
Winslow Homer, American, 1836–1910
The Lookout—"All's Well," 1896
Oil on canvas
101.28 × 76.52 cm (39⅞ × 30⅛ in)
Museum of Fine Arts, Boston
Warren Collection—William Wilkins Warren Fund, 99.23

PAGE 40
Pierre-Auguste Renoir, French, 1841–1919
Dance at Bougival, 1883
Oil on canvas
181.9 × 98.1 cm (71⅝ × 38⅝ in)
Museum of Fine Arts, Boston
Picture Fund, 37.375

PAGE 41
Roman, Imperial Period, AD 14–37
Cameo with Livia Holding a Bust of Augustus (?)
Turquoise
3.1 × 3.8 × 1.6 cm (1¼ × 1½ × ⅝ in)
Museum of Fine Arts, Boston
Henry Lillie Pierce Fund, 99.109

PAGE 43
Egyptian, Late Period, Dynasty 26, 664–525 BC
Vessel (aryballos) in the Form of a Hedgehog
Faience
0.5 cm × 4.5 cm × 7 cm (¹³⁄₆₄ × 1¾ × 2¾ in)
Museum of Fine Arts, Boston
John Wheelock and John Morse Elliot Fund, 1971.145

PAGE 43
Egyptian, Roman Imperial Period, AD 1–99
Vessel with Relief Decoration
Faience
18.2 × 14 cm (7³⁄₁₆ × 5½ in)
Museum of Fine Arts, Boston
Hay Collection—Gift of C. Granville Way, by exchange, 1993.574

PAGE 43
Egyptian, New Kingdom–Late Period, 1550BC–332 BC
Eye of Horus (Wedjat) Amulet
Faience
3.1 × 5 cm (1¼ × 1¹⁵⁄₁₆ in)
Museum of Fine Arts, Boston
Hay Collection—Gift of C. Granville Way, 72.2273

PAGE 45
Nubian, Classic Kerma, ca. 1700–1550 BC
Head of a Nubian
Findspot: Nubia (Sudan), Kerma, Temple K II
Faience
7.5 × 2.3 cm (2⅞ × ⅞ in)
Museum of Fine Arts, Boston
Harvard University–Boston Museum of Fine Arts Expedition, 20.1305a

PAGE 45
Nubian, Classic Kerma, ca. 1700–1550 BC
Figure of a Scorpion
Findspot: Nubia (Sudan), Kerma, K III, comp. 5-3

Glazed quartz
14.4 × 24.3 cm (5¹¹⁄₁₆ × 9⁹⁄₁₆ in)
Museum of Fine Arts, Boston
Harvard University—Boston Museum of Fine Arts
Expedition, 20.1666

PAGE 45
Egyptian, Late–Roman Imperial Period,
760 BC–AD 337
Face of Hathor or Bat
Faience
3.5 × 4.1 cm (1⅜ × 1⅝ in)
Museum of Fine Arts, Boston
Hay Collection–Gift of C. Granville Way, 72.1597

PAGE 46
Egyptian, Third Intermediate Period–Late Period,
Dynasty 21–30, 1070–332 BC
Amulet of Isis and Horus
Faience
5 cm (1¹⁵⁄₁₆ in)
Museum of Fine Arts, Boston
Hay Collection—Gift of C. Granville Way, 72.1831

PAGE 46
Nubian, Classic Kerma, ca. 1700–1550 BC
Head of a Ram
Findspot: Nubia (Sudan), Kerma, Tumulus K III
Glazed quartz
9.4 × 10.6 × 8.3 cm (3¹¹⁄₁₆ × 4³⁄₁₆ × 3¼ in)
Museum of Fine Arts, Boston
Harvard University–Boston Museum of Fine Arts
Expedition, 20.1180
Photographer: Jürgen Liepe

PAGE 46
Egyptian, Late Period, Dynasty 25, 760–660 BC
Head of a King
Findspot: Egypt, Thebes (Karnak)
Blue frit
4.7 cm (1⅞ in)

Museum of Fine Arts, Boston
Emily Esther Sears Fund, 04.1842

PAGE 48
Italic, Etruscan, Late Classical or Hellenistic Period,
late 4th–early 3rd century BC
*Sarcophagus and Lid with Portraits of Husband
and Wife*
Place of Manufacture: Italy, Lazio, Vulci
Volcanic tuff
88 × 73 × 210 cm (34⅝ x 28¾ x 82¹¹⁄₁₆ in)
Museum of Fine Arts, Boston
Museum purchase with funds by exchange from
a Gift of Mr. and Mrs. Cornelius C. Vermeule III,
1975.799

PAGE 49
Roman, Late Imperial Period,
AD mid-4th century
Oval Gem with Bust of Constantius II
Sapphire
15 mm (⅝ in)
Museum of Fine Arts, Boston
Museum purchase with funds donated by
contribution, 01.7543

PAGE 50
Egyptian, New Kingdom, Dynasty 18,
reign of Thutmose IV, 1400–1390 BC
Nemset Vessel
Findspot: Egypt, Thebes, Valley of the Kings, Tomb
of Thutmose IV (KV43)
Faience
10.5 cm (4⅛ in)
Museum of Fine Arts, Boston
Gift of Theodore M. Davis, 03.1106

PAGE 51
Edouard Manet, French, 1832–83
Execution of the Emperor Maximilian, 1867
Oil on canvas

195.9 × 259.7 cm (77⅛ × 102¼ in)
Museum of Fine Arts, Boston
Gift of Mr. and Mrs. Frank Gair Macomber,
30.444

PAGE 52
Nubian, Napatan Period, ca. 750–270 BC
Fragment of Blue Paste or Pigment
Findspot: Nubia (Sudan), Nuri, Pyramid XLVI46,
northwest foundation deposit
Blue paste or pigment
2 cm (¹³⁄₁₆ in)
Museum of Fine Arts, Boston
Harvard University—Boston Museum of Fine Arts
Expedition, 18-2-573

PAGE 53
Chinese, Ming dynasty (1368–1644), Zhengde
period, 1505–21
*Brush Rest with Blue-and-White Decoration and
Arabic Inscription*
Porcelain, Jingdezhen ware
11.8 × 22.3 cm (4⅝ × 8¾ in)
Museum of Fine Arts, Boston
Julia Bradford Huntington James Fund and Gift of
Mrs. Frank Gair Macomber, 13.1626

PAGE 53
Chinese, Ming dynasty, Xuande period, 1426–35
Bowl with Blue-and-White Decoration of Dragons
Porcelain, Jingdezhen ware
11.8 cm (4⅝ in)
Museum of Fine Arts, Boston
Keith McLeod Fund, 63.1083

PAGE 54
Japanese, Edo period, early 19th century
Vase
Object Place: Hirado, Hizen province
Porcelain with underglaze, Hirado ware,
blue decoration

26.8 × 23 cm (10 9/16 × 9 1/16 in)
Museum of Fine Arts, Boston
William Sturgis Bigelow Collection,
21.112

PAGE 54
Egyptian, New Kingdom, Late Dynasty 18,
1390–1327 BC
Amphora with Applied Decoration and Lid
Pottery, Nile silt ware
Height x diameter of rim: 62 × 21 cm
(24 7/16 × 8 1/4 in)
Museum of Fine Arts, Boston
John H. and Ernestine A. Payne Fund, 64.9

PAGE 55
African, Nigerian, mid-20th century
Woman's Wrapper: Adire Oniko
Cotton plain-weave, stitch-resist dyed
168.9 × 196.9 cm (66 1/2 × 77 1/2 in)
Museum of Fine Arts, Boston
Gift of Olaperi Onipede in memory of her parents,
Dr. F. Oladipo Onipede and Mrs. Frances A.
Onipede, 2007.1143

PAGE 56
Giovanni Battista Tiepolo, Italian (Venetian),
1696–1770
Virtue and Nobility Crowning Love, ca. 1759–61
Oil on canvas
377.2 × 302.9 cm (148 1/2 × 119 1/4 in)
Museum of Fine Arts, Boston
Maria Antoinette Evans Fund, 30.539

PAGE 57
French, ca. 1763–68
Potpourri in the Form of a Snail Shell
Made at: Sèvres Manufactory, France
Soft-paste porcelain with colored enamel and gilded
decoration, gilt-bronze mounts
13.1 × 16.3 × 12.8 cm (5 3/16 × 6 7/16 × 5 1/16 in)

Museum of Fine Arts, Boston
Bequest of Forsyth Wickes–The Forsyth Wickes
Collection, 65.1859a-b—65.1860a-b

PAGE 59
Indian, probably 14th century
Cotton Textile Fragments, in Two Pieces
Findspot: Egypt
Cotton plain-weave, resist-dyed
44.5 × 39 cm (17 1/2 × 15 3/8 in)
Museum of Fine Arts, Boston
Harriet Otis Cruft Fund, 48.1051

PAGE 61
Egyptian, New Kingdom, 1550–1070 BC
Fingerless Glove
Linen plain-weave
43 × 13 cm (17 × 5 1/4 in)
Museum of Fine Arts, Boston
Hay Collection—Gift of C. Granville Way, 72.4728

PAGE 61
Italian, 15th century
Velvet with Design of Large Palmettes
Silk voided velvet brocaded with gold metallic
thread
193 × 57 cm (76 × 22 7/16 in)
Museum of Fine Arts, Boston
Gift of Mr. and Mrs. Edward Jackson Holmes,
25.201

PAGE 61
African, Senegal, late 19th to early 20th century
Wrapper
Cotton plain-weave, stitch-resist
243.84 × 121.92 cm (96 × 48 in)
Museum of Fine Arts, Boston
Museum purchase with funds donated by Jeremy
and Hanne Grantham, 2008.1039

PAGE 62
Bromley Hall Print Works, England, 1694–1823
Furnishing Panel: Chinese Figures, after 1774
Cotton plain-weave, copperplate printed
190.5 × 70.5 cm (75 × 27 3/4 in)
Museum of Fine Arts, Boston
Mrs. Samuel Cabot's Special Fund, 47.1549

PAGE 62
Indonesian (Javanese), Dutch colonial rule,
early 20th century
Man's Lower Body Wrapper (Kain)
Cotton plain-weave, hand-drawn (*tulis*), wax-resist
dyed (batik)
101.6 × 256.5 cm (40 × 101 in)
Museum of Fine Arts, Boston
Gift of Ruth Oliver Jolliffe, 2005.1257

PAGE 64
Egyptian, Late Middle Kingdom, Dynasty 12,
1991–1783 BC
Vessel Fragment with Flying Birds
Findspot: Nubia (Sudan), Kerma, Tumulus K XX
Faience
10.3 cm (4 1/16 in)
Museum of Fine Arts, Boston
Harvard University–Boston Museum of Fine Arts
Expedition, 20.1235

PAGE 65
Katsushika Hokusai, Japanese, 1760–1849
Mishima Pass in Kai Province (Kōshū Mishima-goe),
from the series Thirty-Six Views of Mount Fuji
(Fugaku sanjūrokkei)
Japanese, ca. 1830–31, Edo period (1615–1868)
Woodblock print (*nishiki-e*), ink and color on paper
25.2 × 37.7 cm (9 15/16 × 14 13/16 in)
Museum of Fine Arts, Boston
William Sturgis Bigelow Collection, 11.17655

PAGE 66

Chinese, Yuan dynasty, mid-14th century
*Large Plate with Blue-and-White Decoration of a Pair
of Mandarin Ducks in a Lotus Pond* (detail)
Porcelain, Jingdezhen ware decorated with
underglaze cobalt-blue painting
7.5 × 39.5 cm (2¹⁵⁄₁₆ × 15⁵⁄₁₆ in)
Museum of Fine Arts, Boston
Gift of Mr. and Mrs. F. Gordon Morrill, 1982.456

PAGE 67

French (Nevers), Second period, ca. 1740
Quintal Flower Vase
Tin-glazed earthenware
17.14 cm (6¾ in)
Museum of Fine Arts, Boston
The Lloyd and Vivian Hawes Collection, 2000.699

PAGE 67

English (Lambeth), ca. 1680
Bowl
Delft, The Netherlands
Tin-glazed earthenware
7.62 × 17.14 cm (3 × 6¾ in)
Museum of Fine Arts, Boston
Gift of Dr. Lloyd E. Hawes, 61.1241

PAGE 68

Japanese, Edo period (1615–1868), first quarter
of the 18th century
Kimono (Katabira)
Ramie plain-weave, hand-drawn paste resist-dyed
(*yūzen*), hand-painted with ink and embroidered
with silk and gold metallic wrapped threads
162.56 × 119.4 cm (64 × 47 in)
Museum of Fine Arts, Boston
William Sturgis Bigelow Collection, 21.1134

PAGE 69

Italian (Florence), 1575–87
Cruet for Oil and Vinegar

Made by: Medici Factory, Italy
Soft-paste porcelain, underglaze blue decoration
17.1 × 14 × 8.9 cm (6¾ × 5½ × 3½ in)
Museum of Fine Arts, Boston
Gift of the Estate of Professor Henry Williamson
through Miss Sarah H. Blanchard, 12.717

PAGE 70

Nicholas Hilliard, English, ca. 1547–1619
Portrait of a Lady, ca. 1590–95
Watercolor on vellum
5.6 × 4.8 cm (2 ³⁄₁₆ × 1 ⁷⁄₈ in)
Museum of Fine Arts, Boston
Bequest of Nathaniel T. Kidder, 38.1408

PAGE 70

Utagawa Kuniyoshi, Japanese, 1797–1861
*Favorite Customs of the Present Day
(Tōsei fūzoku kō)*
Japanese 1830s, Edo period (1615–1868)
Woodblock print (*aizuri-e*), color on paper
38.4 × 26.2 cm (15⅛ × 10⁵⁄₁₆ in)
Museum of Fine Arts, Boston
William Sturgis Bigelow Collection, 11.15940

PAGE 71

Rogier van der Weyden, Flemish, ca. 1400–64
Saint Luke Drawing the Virgin, ca. 1435–40
Oil and tempera on panel
137.5 × 110.8 cm (54⅛ × 43⅝ in)
Museum of Fine Arts, Boston
Gift of Mr. and Mrs. Henry Lee Higginson, 93.153

PAGE 73

Peter Chang, British, 1944–
Bracelet No. 16, 1990
Object Place: Glasgow, Scotland
Styrofoam core, acrylic, PVC, resin, and lacquer
18 × 16.5 × 6 cm (7¹⁄₁₆ × 6½ × 2⅜ in)
Museum of Fine Arts, Boston

Promised gift of The Daphne Farago Collection
Reproduced with permission.

PAGE 75

Louis Mueller, American, 1943–
Superman Belt Buckle, 1966
Object Place: Rochester, New York
Silver, blue enamel
6.4 × 7.6 × 1.3 cm (2½ × 3 × ½ in)
Museum of Fine Arts, Boston
The Daphne Farago Collection, 2006.376
Reproduced with permission.

PAGE 75

Utagawa Hiroshige I, Japanese, 1797–1858
Japanese, Edo period (1615–1868)
Kingfisher and Wild Rose, 1847–52 (Kōka 4–Kaei 5)
Publisher: Sanoya Kihei (Sanoki, Kikakudō),
Japanese
Woodblock print (*nishiki-e*), ink and color on paper
Aitanzaku; 32.7 × 10.7 cm (12⅞ × 4³⁄₁₆ in)
Museum of Fine Arts, Boston
Denman Waldo Ross Collection, 06.1472

PAGE 75

Possibly English, 18th century
Bishop's Ring
Gold, silver, sapphire, and diamond
Bezel: 2.2 × 1.8 cm (⅞ × ¹¹⁄₁₆ in)
Shank: 2 × 2.2 cm (¹³⁄₁₆ × ⅞ in)
Museum of Fine Arts, Boston
Gift of Mrs. Alice L. Boardman, The William D.
Boardman Collection, 01.5943

PAGE 76

Barbara Natoli Witt, American, 1938–
Necklace #1536, 2011
Gilt silver, gold (14 kt), kingfisher feathers, ruby,
pink tourmaline, turquoise, black spinel, glass, and
silk thread
21.5 × 21 × 1.4 cm (8⁷⁄₁₆ × 8¼ × ⁹⁄₁₆ in)

Museum of Fine Arts, Boston
Gift of the artist Barbara Natoli Witt in memory of her mentor, Eleanor Lambert, 2011.2082
Reproduced with permission.

PAGE 78
Dutch (Delft), late 17th century
Teapot
Tin-glazed earthenware
17 × 14.2 × 11.8 cm (6¹¹⁄₁₆ × 5⁵⁄₁₆ × 4⅝ in)
Museum of Fine Arts, Boston
Arthur Mason Knapp Fund, 1971.399

PAGE 79
Ottoman, Ottoman period, ca. 1573
Tile Lunette
Object Place: Iznik, Turkey
Composite body (quartz, clay, and glaze frit) with colors painted on white slip under clear glaze
70.1 × 141.5 cm (27⅝ × 55¹⁄₁₆ in)
Museum of Fine Arts, Boston
Bequest of Mrs. Martin Brimmer, 06.2437

PAGE 80
Maurice Brazil Prendergast, American (born in Canada), 1858–1924
Flowers in a Blue Vase, ca. 1910–13
Oil on canvas
48.58 × 40.64 cm (19⅛ × 16 in)
Museum of Fine Arts, Boston
Bequest of John T. Spaulding, 48.589

PAGE 81
Dutch (Delft), ca. 1686–95
Gin Bottle
Marked by: Adriaen Kocks, Dutch, Proprietor, The Greek A Factory, active 1687–1701
Tin-glazed earthenware, pewter
25 cm (9¹⁄₁₆ in)
Museum of Fine Arts, Boston

The G. Ephis Collection—Museum purchase with funds donated anonymously, Charles Bain Hoyt Fund, John H. and Ernestine A. Payne Fund, Mary S. and Edward J. Holmes Fund, William Francis Warden Fund, Tamara Petrosian Davis Sculpture Fund, John Lowell Gardner Fund, Seth K. Sweetser Fund, H. E. Bolles Fund, and funds by exchange from the Kiyi and Edward M. Pflueger Collection—Bequest of Edward M. Pflueger and Gift of Kiyi Powers Pflueger, 2012.582a-b

PAGE 81
French (Nevers), 1660–70
Pitcher
Tin-glazed earthenware
24.45 × 14.92 × 12.7 cm (9⅝ × 5⅞ × 5 in)
Museum of Fine Arts, Boston
Gift of Dr. Lloyd E. Hawes, 66.262

PAGE 82
Nubian, Classic Kerma, 1700–1550 BC
Wall Inlay of a Lion
Findspot: Nubia (Sudan), Kerma, Temple K II
Faience
55 × 120 cm (21⅝ × 47¼ in)
Museum of Fine Arts, Boston
Harvard University–Boston Museum of Fine Arts Expedition, 20.1224

PAGE 83
Chinese, Qing dynasty (1644–1912), 19th century
Woman's Headdress (tien tzu)
Gilt metal, kingfisher feathers, jade, tourmaline, coral, turquoise, lapis lazuli, bone, pearl, glass, resin, silk satin-weave, and silk plain-weave
Overall: 21.59 × 24.77 × 19.05 cm
(8½ × 9¾ × 7½ in)
Museum of Fine Arts, Boston
Bequest of Miss Lucy T. Aldrich, RES.55.48

PAGE 84
Tunisian, Fatimid or Abbasid period, 9th or 10th century
Leaf of a Qur'an
Object Place: probably Qairouan, Tunisia
Gold ink on indigo-dyed parchment
28 × 36.5 cm (11 × 14⅜ in)
Museum of Fine Arts, Boston
Samuel Putnam Avery Fund, 33.686

PAGE 85
Katsushika Hokusai, Japanese, 1760–1849
Back View of Fuji from the Minobu River (Minobu-gawa ura Fuji), from the series Thirty-Six Views of Mount Fuji (Fugaku sanjūrokkei)
Japanese, ca. 1830–31, Edo period (1615–1868)
Woodblock print (nishiki-e), ink and color on paper
24.5 × 37.9 cm (9⅝ × 14¹⁵⁄₁₆ in)
Museum of Fine Arts, Boston
William S. and John T. Spaulding Collection, 21.5383

PAGE 85
Katsushika Hokusai, Japanese, 1760–1849
Seven-Mile Beach in Sagami Province (Sōshū Shichiri-ga-hama), from the series Thirty-Six Views of Mount Fuji (Fugaku sanjūrokkei)
Japanese, ca. 1830–31, Edo period (1615–1868)
Woodblock print (nishiki-e), ink and color on paper
25 × 37 cm (9¹³⁄₁₆ × 14⁷⁄₁₆ in)
Museum of Fine Arts, Boston
William S. and John T. Spaulding Collection, 21.6760

PAGE 87
Chinese, late Yuan dynasty, mid-14th century
Wine Jar with Design from a Popular Drama
Porcelain, Jingdezhen ware with cobalt blue underglaze
27.8 × 21 cm (10¹⁵⁄₁₆ × 8¼ in)

Museum of Fine Arts, Boston
Bequest of Charles Bain Hoyt–Charles Bain Hoyt
Collection, 50.1339

PAGE 87
Japanese, late Edo period to Meiji era, 19th century
Vase with Decoration of Birds and Flowers
Porcelain, Arita ware with underglaze blue
decoration
188 × 51 cm (74 × 20⅛ in)
Museum of Fine Arts, Boston
Gift of the Daughters of Julia O. Beals, 1997.211

PAGE 87
Annabeth Rosen, American, 1957–
Wave, 2012
Glazed earthenware, steel wire, steel
182.8 × 208.2 × 86.3 cm (72 × 82 × 34 in)
Museum of Fine Arts, Boston
Museum purchase with funds donated by Martin
and Deborah Hale, 2013.1469
Reproduced with Permission.
Photo Credit: Stewart Clements

PAGE 89
Chinese, Yuan dynasty, mid-14th century
Guan-Type Jar with Lion's-Head Handles
Porcelain, Jingdezhen ware painted with blue
underglaze
37.2 cm (14⅝ in)
Museum of Fine Arts, Boston
Gift of Mabel Hobart Cabot in memory of her
father, Richard B. Hobart, 69.1073

PAGE 89
Felicity Aylieff, English, 1954–
Five Storeys–Chinese Ladders II, 2009
Thrown and glazed porcelain, hand-painted with
"new Ming" cobalt blue and iron oxides
279.4 × 46 cm (110 × 18⅛ in)
Museum of Fine Arts, Boston

Museum purchase with funds donated by Ronald C.
and Anita L. Wornick, 2013.1466
© Felicity Aylieff

PAGE 90
Chinese, Ming dynasty, second quarter of the
17th century
Wine Cup in the Shape of a Shoe
Porcelain, Jingdezhen ware painted in underglaze
blue
5 × 10 cm (1⅞ × 3⅞ in)
Museum of Fine Arts, Boston
Helen S. Coolidge Fund, 1989.207

PAGE 90
Chinese, Yuan dynasty, mid-14th century
*Covered Meiping-Shaped Vase with Blue-and-White
Decoration of Theatrical Figures*
Porcelain, plum blossom vase, Jingdezhen ware
38.6 cm (15³⁄₁₆ in)
Museum of Fine Arts, Boston
Clara Bertram Kimball Collection, by exchange,
37.292

PAGE 90
Chinese, Ming dynasty, Chenghua period, 1465–87
Bowl with Blue-and-White Decoration of Flower Scrolls
Porcelain
6.9 × 14.8 cm (2¹¹⁄₁₆ × 5¹³⁄₁₆ in)
Museum of Fine Arts, Boston
Bequest of Charles Bain Hoyt–Charles Bain Hoyt
Collection, 50.2113

PAGE 92
Egyptian, New Kingdom, Dynasty 18,
1550–1295 BC
Bowl with Fish and Lotuses
Bichrome faience
3.8 × 15.7 cm (1½ × 6³⁄₁₆ in)
Museum of Fine Arts, Boston
William E. Nickerson Fund, 1977.619

PAGE 93
John Singer Sargent, American, 1856–1925
Venice: La Dogana, ca. 1909
Translucent and opaque watercolor over graphite
on paper
50.9 × 35.6 cm (20⅛ × 14 in)
Museum of Fine Arts, Boston
The Hayden Collection–Charles Henry Hayden
Fund, 12.201

PAGE 94
Katsushika Hokusai, Japanese, 1760–1849
*Umezawa Manor in Sagami Province (Sōshū umezawa
zai)*, from the series Thirty-Six Views of Mount Fuji
(Fugaku sanjūrokkei)
Japanese, ca. 1830–31, Edo period (1615–1868)
Woodblock print (*nishiki-e*), ink and color
on paper
24.7 × 36.2 cm (9¾ × 14¼ in)
Museum of Fine Arts, Boston
William S. and John T. Spaulding Collection,
21.5389

PAGE 94
Katsushika Hokusai, Japanese, 1760–1849
Rainstorm beneath the Summit (Sanka haku-u), from
the series Thirty-Six Views of Mount Fuji (Fugaku
sanjūrokkei)
Japanese, ca. 1830–31, Edo period (1615–1868)
Woodblock print (*nishiki-e*), ink and color on paper
24.7 × 36 cm (9¾ × 14³⁄₁₆ in)
Museum of Fine Arts, Boston
William S. and John T. Spaulding Collection,
21.6758

PAGE 95
Austrian, Wiener Werkstätte, ca. 1907
Demitasse Cup and Saucer
Designed by: Otto Prutscher, Austrian, 1880–1949
Manufactured by: Meyr's Neffe Manufactory,
Adolf bei Winterberg, Austria, 1841–1922

Retailed by: E. Bakalowits & Söhne, Vienna, 1845–present
Glass
4.44 × 8.73 × 6.64 cm (1¾ × 3⁷⁄₁₆ × 2⅝ in)
Museum of Fine Arts, Boston
Museum purchase with funds donated by The Swan Society, 1998.402a-b

PAGE 96
Artist/designer: William H. Bradley, American, 1868–1962
The Modern Poster / Charles Scribner's Sons, New York, 1895
Publisher: Charles Scribner's Sons, American, founded in 1846
Relief process, printed in color
51 × 32 cm (20ⁱ⁄₁₆ × 12⅝ in)
Museum of Fine Arts, Boston
Anonymous gift in memory of John G. Pierce, Sr., 65.223

PAGE 97
Egyptian, Late Period, 760–332 BC
Findspot: Egypt
Fragment of a Vessel with Relief Decoration
Faience
5.2 × 3.9 × 0.3 cm (2¹⁄₁₆ × 1⁹⁄₁₆ × ⅛ in)
Museum of Fine Arts, Boston
Gift of Miss Mary S. Ames, 11.1525

PAGE 97
French, ca. 1730
Dress and Petticoat
Silk lampas
Center back (overdress): 152.5 cm (60¹⁄₁₆ in)
Center back (petticoat): 97 cm (38³⁄₁₆ in)
Museum of Fine Arts, Boston
The Elizabeth Day McCormick Collection, 43.664a-b

PAGE 98
John Broadwood & Son, English, active 1795–1808
Grand Piano, 1796
Satinwood, purpleheart, tulipwood
Length: 248.7 cm (97¹⁵⁄₁₆ in); width: 111.5 cm (43⅞ in); case height: 28.4 cm (11³⁄₁₆ in); height with legs: 91.2 cm (35⅞ in)
Museum of Fine Arts, Boston
From the George Alfred Cluett Collection, given by Florence Cluett Chambers, 1985.924

PAGE 99
Katsushika Hokusai, Japanese, 1760–1849
Ejiri in Suruga Province (Sunshū Ejiri), from the series Thirty-Six Views of Mount Fuji (Fugaku sanjūrok-kei), ca. 1830–31
Japanese, ca. 1830–31, Edo period (1615–1868)
Woodblock print (*nishiki-e*), ink and color on paper
25 × 37.7 cm (9¹³⁄₁₆ × 14¹³⁄₁₆ in)
Museum of Fine Arts, Boston
William Sturgis Bigelow Collection, 11.17662

PAGE 99
Katsushika Hokusai, Japanese, 1760–1849
Fine Wind, Clear Weather (Gaifū kaisei), also known as *Red Fuji*, from the series Thirty-Six Views of Mount Fuji (Fugaku sanjūrokkei)
Japanese, ca. 1830–31, Edo period (1615–1868)
Woodblock print (*nishiki-e*), ink and color on paper
24.4 × 38.1 cm (9⅝ × 15 in)
Museum of Fine Arts, Boston
William S. and John T. Spaulding Collection, 21.6756

PAGE 101
Jacopo Tintoretto (Jacopo Robusti), Italian (Venetian), ca. 1518–94
The Nativity (detail), late 1550s, reworked 1570s
Oil on canvas
155.6 × 358.1 cm (61¼ × 141 in)

Museum of Fine Arts, Boston
Gift of Quincy A. Shaw, 46.1430

PAGE 101
Jean Baptiste Isabey, French, 1767–1855
Man in a Blue Striped Waistcoat
Gouache on paper, mounted on card, oval
Museum of Fine Arts, Boston
Gift of Mrs. E. S. Hinds, 57.68

PAGE 103
Claude Monet, French, 1840–1926
Morning on the Seine, Near Giverny, 1897
Oil on canvas
81.3 × 92.7 cm (32 × 36½ in)
Museum of Fine Arts, Boston
Gift of Mrs. W. Scott Fitz, 11.1261

PAGE 105
Sandro Botticelli, Italian (Florentine), 1444 or 1445–1510
Virgin and Child with Saint John the Baptist, ca. 1500
Tempera on panel
123.8 × 84.4 cm (48¾ × 33¼ in)
Museum of Fine Arts, Boston
Sarah Greene Timmins Fund, 95.1372

PAGE 105
Gherardo di Jacopo Starnina, Italian (Florentine), ca. 1360–1413
Saint Stephen, ca. 1410
Tempera on panel
66.9 × 33.3 cm (26⅓ × 13⅛ in)
Museum of Fine Arts, Boston
Gift of Mrs. Thomas O. Richardson, 20.1855b

PAGE 106
Corneille de Lyon, French, active by 1533, died in 1575

Portrait of a Man, Identified as Anne de Montmorency (1493–1567), 1533 or 1536
Oil on panel
16.5 × 13.3 cm (6½ × 5¼ in)
Museum of Fine Arts, Boston
Charles Augustus Vialle Fund, 24.264

PAGE 107
Nubian, Classic Kerma, ca. 1700–1550 BC
Ceiling Block with Rosette Pattern
Findspot: Nubia (Sudan), Kerma, Temple XI
Sandstone and faience
93.5 × 75 cm (36¹³⁄₁₆ × 29½ in)
Museum of Fine Arts, Boston
Harvard University–Boston Museum of Fine Arts
Expedition, 13.4360.1

PAGE 107
French, 1753
Covered Water Jug
Made at: Vincennes Manufactory, France
Soft-paste porcelain decorated in polychrome
enamels and gold, gold mounts
Without mount: 19.4 × 14.5 × 11.9 cm
(7⅝ × 5¹¹⁄₁₆ × 4¹¹⁄₁₆ in)
Museum of Fine Arts, Boston
Bequest of Forsyth Wickes–The Forsyth Wickes
Collection, 65.1816

PAGE 108
Jean-Honoré Fragonard, French, 1732–1806
Aurora Triumphing over Night, ca. 1755–56
Oil on canvas
95.3 × 131.4 cm (37½ × 51¾ in)
Museum of Fine Arts, Boston
Museum purchase with funds by exchange by contri-
bution, and by exchange from a Gift of Laurence
K. and Lorna J. Marshall, 2013.62

PAGE 109
Egyptian, Roman Imperial Period

(30 BC–AD 364)
Vessel with Lid, AD 1–50
Faience
19.5 cm (7¹¹⁄₁₆ in)
Museum of Fine Arts, Boston
Florence E. and Horace L. Mayer Fund,
2011.1635a-b

PAGE 110
Egyptian, New Kingdom, 1550–1070 BC
Amulet of a Frog
Faience
1.3 cm (½ in)
Museum of Fine Arts, Boston
Hay Collection–Gift of C. Granville Way, 72.2509

PAGE 110
East Greek, Late Period, 600–500 BC
Cosmetic Box with Frog
Faience
Box: 2.2 × 7 cm (⅞ × 2¾ in)
Lid: 2.8 × 7 cm (1⅛ × 2¾ in)
Museum of Fine Arts, Boston
Edward J. and Mary S. Holmes Fund, 1970.571

PAGE 111
Egyptian, New Kingdom, 1550–1070 BC
Eye of Horus (Wedjat) Amulet
Findspot: Nubia (Sudan), Semna,
River Street, fort
Faience, ivory, glass paste
2.6 × 3.6 cm (1¹⁄₁₆ × 1⁷⁄₁₆ in)
Museum of Fine Arts, Boston
Harvard University–Boston Museum of Fine Arts
Expedition, 27.884

PAGE 112
Katsushika Hokusai, Japanese, 1760–1849
*The Amida Falls in the Far Reaches of the Kisokaidō
Road (Kisoji no oku Amida-ga-taki)*, from the
series A Tour of Waterfalls in Various Provinces

(Shokoku taki meguri)
Japanese, ca. 1832, Edo period (1615–1868)
Woodblock print (*nishiki-e*), ink and color
on paper
36.1 × 25.7 cm (14³⁄₁₆ × 10⅛ in)
Museum of Fine Arts, Boston
William S. and John T. Spaulding Collection,
21.6687

PAGE 112
Egyptian, Third Intermediate Period–Late Period,
Dynasty 21–30, 1070–332 BC
Amulet of Harpokrates
Faience
2.2 cm (⅞ in)
Museum of Fine Arts, Boston
Hay Collection–Gift of C. Granville Way, 72.1953

PAGE 113
George Inness, American, 1825–94
Blue Niagara, 1884
Oil on canvas
122.87 × 183.51 cm (48⅜ × 72¼ in)
Museum of Fine Arts, Boston
Charles H. Bayley Picture and Painting Fund,
1982.209

PAGE 115
French, 1779
Vase
Made at: Sèvres Manufactory, France
Painted by: Antoine Caton, French,
active 1749–97
Painted by: Charles Buteux, l'aîné, père, French,
active 1756–82
Gilder: Etienne-Henri Le Guay, l'aîné, père, French,
1719–99, active at Sèvres 1742–43, 1748–49,
1751–96
Soft-paste porcelain with dark blue (bleu
nouveau) ground, with reserves decorated in poly-
chrome enamels, gilding

71 cm (27⅞ in)
Museum of Fine Arts, Boston
Bequest of Miss Elizabeth Howard Bartol,
27.534a-b

PAGE 115
Japanese export, ca. 1660–80
"Kraak" Plate
Hard-paste porcelain with underglaze blue
decoration
45 cm (17¹¹⁄₁₆ in)
Museum of Fine Arts, Boston
The G. Ephis Collection—Museum purchase with
funds donated anonymously, Charles Bain Hoyt
Fund, John H. and Ernestine A. Payne Fund, Mary
S. and Edward J. Holmes Fund, William Francis
Warden Fund, Tamara Petrosian Davis Sculpture
Fund, John Lowell Gardner Fund, Seth K. Sweetser
Fund, H. E. Bolles Fund, and funds by exchange
from the Kiyi and Edward M. Pflueger Collection—
Bequest of Edward M. Pflueger and Gift of Kiyi
Powers Pflueger, 2012.570

PAGE 115
Dutch (Delft), ca. 1680
Sweetmeat Set
Marked by: Samuel van Eenhoorn (Dutch),
proprietor, The Greek A Factory, active 1674–86
Tin-glazed earthenware
72.4 cm (28½ in)
Museum of Fine Arts, Boston
The G. Ephis Collection—Museum purchase with
funds donated anonymously, Charles Bain Hoyt
Fund, John H. and Ernestine A. Payne Fund, Mary
S. and Edward J. Holmes Fund, William Francis
Warden Fund, Tamara Petrosian Davis Sculpture
Fund, John Lowell Gardner Fund, Seth K. Sweetser
Fund, H. E. Bolles Fund, and funds by exchange
from the Kiyi and Edward M. Pflueger Collection—
Bequest of Edward M. Pflueger and Gift of Kiyi
Powers Pflueger, 2012.576.1-9

PAGE 117
English (Staffordshire), ca. 1820–35
Plate
Clews Manufactory, Staffordshire, England,
active ca. 1818–36
Lead-glazed earthenware (pearlware),
transfer-printed decoration
26 cm (10¼ in.)
Museum of Fine Arts, Boston
Bequest of George Washington Wales, 03.337

PAGE 117
English, ca. 1785–95
*Potpourri Vase with Perforated Cover, Depicting
Apollo and the Nine Muses*
Made at: Wedgwood Manufactory, Staffordshire,
England
Stoneware (jasperware)
24 cm (9⁷⁄₁₆ in)
Museum of Fine Arts, Boston
Bequest of Mrs. Thomas O. Richardson, 25.282a-b

PAGE 117
Persian, Safavid period, second quarter of the
17th century
Dish
Stonepaste or fritware with underglaze blue
decoration
46.5 cm (18¹⁵⁄₁₆ in)
Museum of Fine Arts, Boston
The G. Ephis Collection—Museum purchase with
funds donated anonymously, Charles Bain Hoyt
Fund, John H. and Ernestine A. Payne Fund, Mary
S. and Edward J. Holmes Fund, William Francis
Warden Fund, Tamara Petrosian Davis Sculpture
Fund, John Lowell Gardner Fund, Seth K. Sweetser
Fund, H. E. Bolles Fund, and funds by exchange
from the Kiyi and Edward M. Pflueger Collection—
Bequest of Edward M. Pflueger and Gift of Kiyi
Powers Pflueger, 2012.571

PAGE 118
Dutch (Delft), ca. 1660–80
"Kraak" Bottle
Tin-glazed earthenware
27.8 cm (10¹⁵⁄₁₆ in)
Museum of Fine Arts, Boston
The G. Ephis Collection—Museum purchase with
funds donated anonymously, Charles Bain Hoyt
Fund, John H. and Ernestine A. Payne Fund, Mary
S. and Edward J. Holmes Fund, William Francis
Warden Fund, Tamara Petrosian Davis Sculpture
Fund, John Lowell Gardner Fund, Seth K. Sweetser
Fund, H. E. Bolles Fund, and funds by exchange
from the Kiyi and Edward M. Pflueger Collection—
Bequest of Edward M. Pflueger and Gift of Kiyi
Powers Pflueger, 2012.573

PAGE 118
English, 1785–90
Cream Jug
Made at: Wedgwood Manufactory, Staffordshire,
England
Colored stoneware (jasperware)
6.8 × 10.9 × 6.5 cm (2¹¹⁄₁₆ × 4�5⁄₁₆ × 2⁹⁄₁₆ in)
Museum of Fine Arts, Boston
Bequest of George Washington Wales, 03.267

PAGE 118
English, 1785–90
Sugar Bowl
Made at: Wedgwood Manufactory, Staffordshire,
England
Colored stoneware (jasperware)
11.3 cm (4⁷⁄₁₆ in)
Museum of Fine Arts, Boston
Bequest of George Washington Wales, 03.266a-b

PAGE 121
French, ca. 1785–90
Potpourri Vase
Made at: Sèvres Manufactory, France

Hard-paste porcelain, gilt-bronze mounts,
marble plinth
31 cm (12³⁄₁₆ in)
Museum of Fine Arts, Boston
Charles Hitchcock Tyler Residuary Fund, 44.74a-b

PAGE 121
Portuguese, 17th century
"Kraak" Plate
Tin-glazed earthenware
37 cm (14⁹⁄₁₆ in)
Museum of Fine Arts, Boston
The G. Ephis Collection—Museum purchase with
funds donated anonymously, Charles Bain Hoyt
Fund, John H. and Ernestine A. Payne Fund, Mary
S. and Edward J. Holmes Fund, William Francis
Warden Fund, Tamara Petrosian Davis Sculpture
Fund, John Lowell Gardner Fund, Seth K. Sweetser
Fund, H. E. Bolles Fund, and funds by exchange
from the Kiyi and Edward M. Pflueger Collection—
Bequest of Edward M. Pflueger and Gift of Kiyi
Powers Pflueger, 2012.572

PAGE 121
English, ca. 1780
Plate
Made at: Bow Manufactory, England
Soft-paste porcelain
19.1 cm (7½ in)
Museum of Fine Arts, Boston
Gift of Mrs. Charles A. King, RES.38.42

PAGE 122
Egyptian, Third Intermediate Period, 1075–656 BC
Bowl with Cows
Findspot: Nubia (Sudan), el-Kurru, Kurru 55
Faience
4.4 × 16.4 cm (1¾ × 6⁷⁄₁₆ in)
Museum of Fine Arts, Boston
Harvard University–Boston Museum of Fine Arts
Expedition, 24.1089

PAGE 123
Paul Cézanne, French, 1839–1906
Fruit and a Jug on a Table, ca. 1890–94
Oil on canvas
32.4 × 40.6 cm (12¾ × 16 in)
Museum of Fine Arts, Boston
Bequest of John T. Spaulding, 48.524

PAGE 124
Paul Gauguin, French, 1848–1903
*Where Do We Come From? What Are We? Where Are
We Going?* 1897–98
Oil on canvas
139.1 × 374.6 cm (54¾ × 147½ in)
Museum of Fine Arts, Boston
Tompkins Collection–Arthur Gordon Tompkins
Fund, 36.270

PAGE 125
Egyptian, Late–Hellenistic (Ptolemaic) Period,
760 BC–30 BC
Inlay in the Form of an Owl
Faience
2.7 × 2 cm (1¹⁄₁₆ × ¹³⁄₁₆ in)
Museum of Fine Arts, Boston
Gift of Mr. and Mrs. Perry T. Rathbone, 1971.773

PAGE 126
Laura Coombs Hills, American, 1859–1952
The Nymph, 1908
Watercolor on ivory
14.6 × 11.43 cm (5¾ × 4½ in)
Museum of Fine Arts, Boston
Abbott Lawrence Fund, 26.30

PAGE 126
English, ca. 1785–90
Tea Canister
Made at: Wedgwood Manufactory, Staffordshire,
England
Colored stoneware (jasperware)

13.9 cm (5½ in)
Museum of Fine Arts, Boston
Bequest of Mrs. Richard Baker, 96.761a-b

PAGE 127
Max Weber, American (born in Russia), 1881–1961
New York (The Liberty Tower from the Singer Building),
1912
Oil on canvas
46.35 × 33.34 cm (18¼ × 13⅛ in)
Museum of Fine Arts, Boston
Gift of the Stephen and Sybil Stone Foundation,
1971.705

PAGE 128
Chinese export, Wanli period, 1573–1610
Plate
Hard-paste porcelain with underglaze blue
decoration
26 cm (10¼ in)
Museum of Fine Arts, Boston
The G. Ephis Collection—Museum purchase with
funds donated anonymously, Charles Bain Hoyt
Fund, John H. and Ernestine A. Payne Fund, Mary
S. and Edward J. Holmes Fund, William Francis
Warden Fund, Tamara Petrosian Davis Sculpture
Fund, John Lowell Gardner Fund, Seth K. Sweetser
Fund, H. E. Bolles Fund, and funds by exchange
from the Kiyi and Edward M. Pflueger Collection—
Bequest of Edward M. Pflueger and Gift of Kiyi
Powers Pflueger, 2012.568

PAGE 129
Katsushika Hokusai, Japanese, 1760–1849
In the Mountains of Tōtōmi Province (Tōtōmi sanchū),
from the series Thirty-Six Views of Mount Fuji
(Fugaku sanjūrokkei)
Japanese, ca. 1830–31, Edo period (1615–1868)
Woodblock print (*nishiki-e*), ink and color
on paper; the first printing, with blue outlines.
25.1 × 37.7 cm (9⅞ × 14¹³⁄₁₆ in)

Museum of Fine Arts, Boston
William Sturgis Bigelow Collection, 11.19717

PAGE 129
Katsushika Hokusai, Japanese (1760–1849)
In the Mountains of Tōtōmi Province (Tōtōmi sanchū),
from the series Thirty-Six Views of Mount Fuji
(Fugaku sanjūrokkei)
Japanese, ca. 1830–31, Edo period (1615–1868)
Woodblock print (nishiki-e), ink and color
on paper; a later printing with black outlines and
a full range of colors.
25.3 × 37 cm (9¹⁵⁄₁₆ × 14⁹⁄₁₆ in)
Museum of Fine Arts, Boston
William Sturgis Bigelow Collection, 11.17658

PAGE 131
Katsushika Hokusai, Japanese, 1760–1849
Ushibori in Hitachi Province (Jōshū Ushibori),
from the series Thirty-Six Views of Mount Fuji
(Fugaku sanjūrokkei)
Japanese, ca. 1830–31, Edo period (1615–1868)
Woodblock print (nishiki-e), ink and color on paper
25.2 × 37.4 cm (9⁷⁄₁₆ × 14¾ in)
Museum of Fine Arts, Boston
Gift of C. Adrian Rübel, 46.1405

PAGE 133
Katsushika Hokusai, Japanese, 1760–1849
*Under the Wave off Kanagawa (Kanagawa-oki
nami-ura)*, also known as *The Great Wave*, from the
series Thirty-Six Views of Mount Fuji (Fugaku
sanjūrokkei)
Japanese, ca. 1830–31, Edo period (1615–1868)
Woodblock print (nishiki-e), ink and color on paper
25.8 × 38 cm (10³⁄₁₆ × 14¹⁵⁄₁₆ in)
Museum of Fine Arts, Boston
William S. and John T. Spaulding Collection,
21.6765

PAGE 135
Katsushika Hokusai, Japanese, 1760–1849
Lake Suwa in Shinano Province (Shinshū Suwako),
from the series Thirty-Six Views of Mount Fuji
(Fugaku sanjūrokkei)
Japanese, ca. 1830–31, Edo period (1615–1868)
Woodblock print (nishiki-e), ink and color on paper
25.7 × 38 cm (10⅛ × 14¹⁵⁄₁₆ in)
Museum of Fine Arts, Boston
William S. and John T. Spaulding Collection,
21.5391

PAGE 135
Katsushika Hokusai, Japanese, 1760–1849
*Hongan-ji Temple at Asakusa in Edo (Tōto Asakusa
hongan-ji)*, from the series Thirty-Six Views of
Mount Fuji (Fugaku sanjūrokkei)
Japanese, ca. 1830–31, Edo period (1615–1868)
Woodblock print (nishiki-e), ink and color on paper
25 × 38 cm (9¹³⁄₁₆ × 14¹⁵⁄₁₆ in)
Museum of Fine Arts, Boston
William S. and John T. Spaulding Collection,
21.6779

PAGE 136
Katsushika Hokusai, Japanese, 1760–1849
Tsukudajima in Musashi Province (Buyō Tsukudajima),
from the series Thirty-Six Views of Mount Fuji
(Fugaku sanjūrokkei), ca. 1830–31
Japanese, ca. 1830–31, Edo period (1615–1868)
Woodblock print (nishiki-e), ink and color on paper
25.7 × 38.1 cm (10⅛ × 15 in)
Museum of Fine Arts, Boston
Gift of Mr. and Mrs. Yves Henry Buhler, 52.950

PAGE 137
Egyptian, Hellenistic Period (Ptolemaic Dynasty),
305–30 BC
Amulet of a Queen
Findspot: Egypt, Tel Nabasha
Faience

5.9 cm (2⁵⁄₁₆ in)
Museum of Fine Arts, Boston
Egypt Exploration Fund by subscription, 87.562

PAGE 137
Egyptian, New Kingdom, Dynasty 18,
reign of Thutmose III, 1479–1425 BC
Kohl Jar with Lid
Findspot: Egypt, Abydos, Tomb D 10
Glazed steatite
3.8 × 3.8 cm (1½ × 1½ in)
Museum of Fine Arts, Boston
Egypt Exploration Fund by subscription, 00.701a-b

PAGE 138
Egyptian, Roman Imperial Period, 30 BC–AD 364
Jug (oinochoe)
Glass
14.5 cm (5⅝ in)
Museum of Fine Arts, Boston
Gift of Horace L. Mayer, 65.1748

PAGE 138
Nubian, Meroitic period, AD 20–90
Amulet of Isis and Horus
Findspot: Nubia (Sudan), Meroe, Beg. W27
Blue frit
3.5 cm (1⅜ in)
Museum of Fine Arts, Boston
Harvard University–Boston Museum of Fine Arts
Expedition, 222449

PAGE 139
Anthony van Dyck, Flemish, 1599–1641
Princess Mary, Daughter of Charles I, ca. 1637
Oil on canvas
132.1 × 106.3 cm (52 × 41⅞ in)
Museum of Fine Arts, Boston
Given in memory of Governor Alvan T. Fuller by the
Fuller Foundation, 61.391

PAGE 140
Fra Angelico, Italian (Florentine),
ca. 1395/1400–1455
Virgin and Child Enthroned with Saints Peter, Paul and George (?), Four Angels, and a Donor, ca. 1446–49
Tempera on panel
24.9 × 24.8 cm (9¹³⁄₁₆ × 9¾ in)
Museum of Fine Arts, Boston
Gift of Mrs. Walter Scott Fitz, 14.416

PAGE 141
Dutch (Delft), ca. 1686–92
Pair of Double Gourd-Shaped Bottles
Made by: The Young Moor's Head Factory,
active 1686–92
Marked by: Rochus Jacobsz. Hoppesteyn, Dutch,
active 1686–92
Tin-glazed earthenware
48 cm (18⅞ in)
Museum of Fine Arts, Boston
The G. Ephis Collection—Museum purchase with funds donated anonymously, Charles Bain Hoyt Fund, John H. and Ernestine A. Payne Fund, Mary S. and Edward J. Holmes Fund, William Francis Warden Fund, Tamara Petrosian Davis Sculpture Fund, John Lowell Gardner Fund, Seth K. Sweetser Fund, H. E. Bolles Fund, and funds by exchange from the Kiyi and Edward M. Pflueger Collection—Bequest of Edward M. Pflueger and Gift of Kiyi Powers Pflueger, 2012.575.1–2

PAGE 142
French, ca. 1771
Wine Cooler from the Prince de Rohan Service
Made at: Sèvres Manufactory, France
Painted by: Etienne Evans, French, born 1733,
active 1752–1806
Soft-paste porcelain, overglaze enamels, gilding
17.4 cm (6⅞ in)
Museum of Fine Arts, Boston
Gift of John Fox, 46.8

PAGE 143
Georgia O'Keeffe, American, 1887–1986
Fishhook from Hawaii No. 2, 1939
Oil on canvas
91.12 × 60.64 cm (35⅞ × 23⅞ in)
Museum of Fine Arts, Boston
Alfred Stieglitz Collection—Bequest of Georgia O'Keeffe, 1987.540

PAGE 143
Japanese, artist unknown, early Shōwa era,
1926–45
To Tomita Beach, 1936
Color lithograph, ink on coated paper
13.8 × 8.8 cm (5⁷⁄₁₆ × 3⁷⁄₁₆ in)
Museum of Fine Arts, Boston
Leonard A. Lauder Collection of Japanese Postcards, 2002.1635

PAGE 145
Henry Peter Bosse, American, born in Germany,
1844–1903
U.S. Steamlaunch "Louise," near Keokuk, IA, 1885
Cyanotype
36.5 × 43.7 cm (14⅜ × 17³⁄₁₆ in)
Museum of Fine Arts, Boston
Edward J. and Mary S. Holmes Fund, 2010.504

PAGE 147
Christian Marclay, American, 1955–
Allover (The Oak Ridge Boys, Rollins Band, Styx, and Others), 2009
Cyanotype
130.8 × 254 cm (51½ × 100 in)
Museum of Fine Arts, Boston
Towles Contemporary Art Fund, 2009.3990
© Christian Marclay

PAGE 149
Arthur Wesley Dow, American, 1857–1922
Salt Marsh, ca. 1904

Cyanotype
12.0 × 16.8 cm (4¾ × 6⅝ in)
Museum of Fine Arts, Boston
A. Shuman Collection—Abraham Shuman Fund,
1983.186

PAGE 150
Anna Atkins, English, 1799–1871
Thistle (Carduus acanthoides), 1851–54
Cyanotype
34.9 × 24.8 cm (13¾ × 9¾ in)
Museum of Fine Arts, Boston
Sophie M. Friedman Fund, 1986.593

PAGE 150
Egyptian, New Kingdom, late Dynasty 18–
early Dynasty 19, 1550–1213 BC
Shawabti of the Priest of Sekhmet Huy
Findspot: Egypt, Abydos, Cemetery G
Faience
16.5 × 6.2 × 3.7 cm (6½ × 2⁷⁄₁₆ × 1⁷⁄₁₆ in)
Museum of Fine Arts, Boston
Egyptian Exploration Fund by subscription,
00.698

PAGE 151
Vincent van Gogh, Dutch (worked in France),
1853–90
Postman Joseph Roulin, 1888
Oil on canvas
81.3 × 65.4 cm (32 × 25¾ in)
Museum of Fine Arts, Boston
Gift of Robert Treat Paine, 2nd, 35.1982

PAGE 152
English, ca. 1758–69
Dish
Made at: Chelsea Manufactory, England,
active 1745–1769
Soft-paste porcelain
22.9 × 33 cm (9 × 13 in)

Museum of Fine Arts, Boston
Gift of Richard C. Paine, 30.354

PAGE 153
Norman Lewis, American, 1909–79
Harlem Jazz Jamboree, 1943
Oil on canvas
45.7 × 40.6 cm (18 × 16 in)
Museum of Fine Arts, Boston
Charles H. Bayley Picture and Painting Fund,
2007.5
The Estate of Norman Lewis, Courtesy of Landor
Fine Arts, New Jersey
Reproduced with permission.

PAGE 154
Nubian, Classic Kerma, ca. 1700–1550 BC
Forepart of a Reclining Lion
Findspot: Nubia (Sudan), Kerma, Chapel K II: A
Glazed quartzite
8.4 × 12 cm (3 5/16 × 4 3/4 in)
Museum of Fine Arts, Boston
Harvard University—Boston Museum of Fine Arts
Expedition, 13.4229

PAGE 154
Roman, 1st century BC–AD 1st century
Cast Rib Blue Bowl
Glass
4 × 13 cm (1 9/16 × 5 1/8 in)
Museum of Fine Arts, Boston
M. Elizabeth Carter Collection—Anonymous gift,
18.254

PAGE 155
Elsa Freund, American, 1912–2001
Space Pendant with Circlet, ca. 1960
Object Place: Eureka Springs, Arkansas,
or Deland, Florida
Silver, glass, terra-cotta
19.1 × 11.4 × 1.3 cm, 49.1 g (7 1/2 × 4 1/2 × 1/2 in, 0.1 lb)

Museum of Fine Arts, Boston
The Daphne Farago Collection, 2006.208
Reproduced with permission.

PAGE 156
Rembrandt Harmensz. van Rijn, Dutch, 1606–69
Artist in His Studio, ca. 1628
Oil on panel
24.8 × 31.7 cm (9 3/4 × 12 1/2 in)
Museum of Fine Arts, Boston
Zoe Oliver Sherman Collection, given in memory
of Lillie Oliver Poor, 38.1838

PAGE 157
Egyptian, Late Period, Dynasty 26, 664–525 BC
Shawabti of Neferseshempsamtik
Faience
19 × 5 cm (7 1/2 × 1 15/16 in)
Museum of Fine Arts, Boston
Hay Collection—Gift of C. Granville Way, 72.1675

PAGE 157
Egyptian, Third Intermediate Period–Late Period,
Dynasty 2, 1070–332 BC
Amulet of Nefertum
Faience
6 cm (2 3/8 in)
Museum of Fine Arts, Boston
Hay Collection—Gift of C. Granville Way, 72.1926

PAGE 159
Joseph Stella, American, 1877–1946
Old Brooklyn Bridge, ca. 1941
Oil on canvas
193.67 × 173.35 cm (76 1/4 × 68 1/4 in)
Museum of Fine Arts, Boston
Gift of Susan Morse Hilles in memory of Paul
Hellmuth, 1980.197

PAGE 159
National String Instrument Corporation, American
Resonator Guitar (Tricone Model), 1934
Nickel silver, ebony, plastic
98 × 36.2 × 8.4 cm (38 9/16 × 14 1/4 × 9 5/16 in)
Museum of Fine Arts, Boston
Helen B. Sweeney Fund, 1998.193

PAGE 161
Attributed to: Boston and Sandwich Glass Company,
1826–1888
Paneled Door from Roswell Gleason House,
ca. 1845–60
Glass, painted pine
335.28 × 106.68 cm (132 × 42 in)
Museum of Fine Arts, Boston
H. E. Bolles Fund, 1976.671

PAGE 161
Louis F. Vaupel, American (born in Germany),
1824–1903
Goblet, ca. 1860–75
New England Glass Co., East Cambridge,
Massachusetts, 1818–1888
Blown, cobalt-blue cased glass, cut and engraved
15.87 × 7.62 × 7.62 cm (6 1/4 × 3 × 3 in)
Museum of Fine Arts, Boston
Bequest of Dr. Minette D. Newman, 61.1219

PAGE 162
American, ca. 1700–50
Apothecary Jar
Tin-glazed earthenware
26.03 × 11.43 × 11.43 cm (10 1/4 × 4 1/2 × 4 1/2 in)
Museum of Fine Arts, Boston
Denman Waldo Ross Collection, 02.325

PAGE 162
American, ca. 1855–59
Pot
Object Place: Bennington, Vermont, United States

Made at: J. and E. Norton Pottery, active 1850–59
Decorated by: John Hilfinger, 1826–88
Stoneware with cobalt-blue decoration
30.48 × 33.02 × 33.02 cm (12 × 13 × 13 in)
Museum of Fine Arts, Boston
Gift of Mrs. Lloyd E. Hawes, in memory of Nina
Fletcher Little, 1993.546

PAGE 164

Egyptian, New Kingdom–Late Period,
1550 BC–332 BC
Amulet of Isis and Horus
Faience
7.5 cm (2¹⁵⁄₁₆ in)
Museum of Fine Arts, Boston
Gift of Mrs. Samuel D. Warren, 94.261

PAGE 164

Egyptian, Old Kingdom, Dynasty 4, reign of Khufu,
2551–2528 BC
Beadnet Dress
Findspot: Egypt, Giza, Tomb G 7440 Z
Faience
44 × 113 cm (17⁵⁄₁₆ × 44½ in)
Mount: 139.7 × 31.8 × 17.8 cm (55 × 12½ × 7 in)
Museum of Fine Arts, Boston
Harvard University—Boston Museum of Fine Arts
Expedition, 27.1548.1

PAGE 165

Tomie Nagano, Japanese, 1950–
Quilt: Katazome Indigo Cotton, from the series
Two Hearts in Harmony, 2000
Cotton plain-weave, stencil-dyed with indigo, hand-
pieced and hand-quilted with polyester thread
241 × 240 cm (94⅞ × 94½ in)
Museum of Fine Arts, Boston
Gift of Wayne E. Nichols 2012.1018
Reproduced with permission.

PAGE 166

French, 1771–72
Plate
Made at: Sèvres Manufactory, France
Soft-paste porcelain, overglaze enamels, gilding
Museum of Fine Arts, Boston
Gift of John Fox, 46.7

PAGE 167

Japanese, Meiji or Taishō era, late 19th to
early 20th century
Kimono (Yukata)
Cotton plain-weave, tie-dyed and stitch
resist-dyed (*nuishime shibori*)
133.4 × 120.0 cm (52½ × 47¼ in)
Museum of Fine Arts, Boston
William Sturgis Bigelow Collection, 21.1128

PAGE 168

Katsushika Hokusai, Japanese, 1760–1849
Kajikazawa in Kai Province (Kōshū Kajikazawa), from
the series Thirty-Six Views of Mount Fuji (Fugaku
sanjūrokkei)
Japanese, ca. 1830–31, Edo period (1615–1868)
Woodblock print (*nishiki-e*), ink and color
on paper
26 × 38 cm (10¼ × 14¹⁵⁄₁₆ in)
Museum of Fine Arts, Boston
William S. and John T. Spaulding Collection,
21.6774

PAGE 168

Katsushika Hokusai, Japanese, 1760–1849
*Fuji View Plain in Owari Province (Bishū Fujimi-
ga-hara)*, from the series Thirty-Six Views of Mount
Fuji (Fugaku sanjūrokkei)
Japanese, ca. 1830–31, Edo period (1615–1868)
Woodblock print (*nishiki-e*), ink and color
on paper
25.2 × 37.7 cm (9¹⁵⁄₁₆ × 14¹³⁄₁₆ in)

Museum of Fine Arts, Boston
William Sturgis Bigelow Collection, 11.17649

PAGE 169

Duccio di Buoninsegna and Workshop, Italian
(Sienese), active in 1278, died by 1319
*Triptych: the Crucifixion; the Redeemer with Angels;
Saint Nicholas; Saint Gregory*, 1311–18
Tempera on panel
Center: 61.0 × 39.4 cm (24 × 15½ in)
Left: 45.1 × 19.4 cm (17¾ × 7⅝ in)
Right: 45.1 × 20.2 cm (17¾ × 7¹⁵⁄₁₆ in)
Museum of Fine Arts, Boston
Grant Walker and Charles Potter Kling Funds,
45.880

PAGE 170

Egyptian, New Kingdom, Dynasty 18, reign of
Amenhotep III, 1390–1353 BC
Head of the God Bes
Egyptian blue
3.81 × 4.5 cm (1½ × 1¾ in)
Museum of Fine Arts, Boston
Henry Lillie Pierce Fund, 98.942

PAGE 171

Italian (Urbino or Urbino region), Renaissance,
ca. 1515–30
*Plate from a Service Made for the Peroli Family
of Urbino*
Tin-glazed earthenware (majolica)
4.1 × 27.6 cm (1⅝ × 10⅞ in)
Museum of Fine Arts, Boston
Harriet Otis Cruft Fund, 55.931

PAGE 172

Charles Herbert Woodbury, American, 1864–1940
Off the Florida Coast, ca. 1902
Oil on canvas
73.34 × 91.76 cm (28⅞ × 36⅛ in)

Museum of Fine Arts, Boston
Gift of Subscribers, 05.47

PAGE 173

English (Burslem), ca. 1814–18
Pitcher
Earthenware, copper luster glaze
Manufactured by: Wood & Caldwell, active
ca. 1790–1818
25.4 × 20.3 × 15.2 cm (10 × 8 × 6 in)
Museum of Fine Arts, Boston
Alice M. Bartlett Fund, 2011.97

PAGE 192

Utagawa Hiroshige I, Japanese, 1797–1858
Bird and Loquat
Japanese, ca. 1830–44, Edo period (1615–1868)
Woodblock print (*aizuri-e*), color on paper
37.4 × 16.5 cm (14¾ × 6½ in)
Museum of Fine Arts, Boston
William S. and John T. Spaulding Collection, 21.7917

UTAGAWA HIROSHIGE *Bird and Loquat, ca. 1830–44*

Library of Congress Cataloging-in-Publication Data available.

ISBN: 978-1-4521-2940-2

Manufactured in China

MIX
Paper from responsible sources
FSC™ C104723

Design and typesetting by Annabelle Gould
Typeset with Arnhem, Egyptian, Brandon Grotesque, and Stag Stencil

10 9 8 7 6 5 4 3 2 1

Chronicle Books LLC
680 Second Street
San Francisco, CA 94107
www.chroniclebooks.com